# Mastering Color

## The Essentials of Color Illustrated With Oils

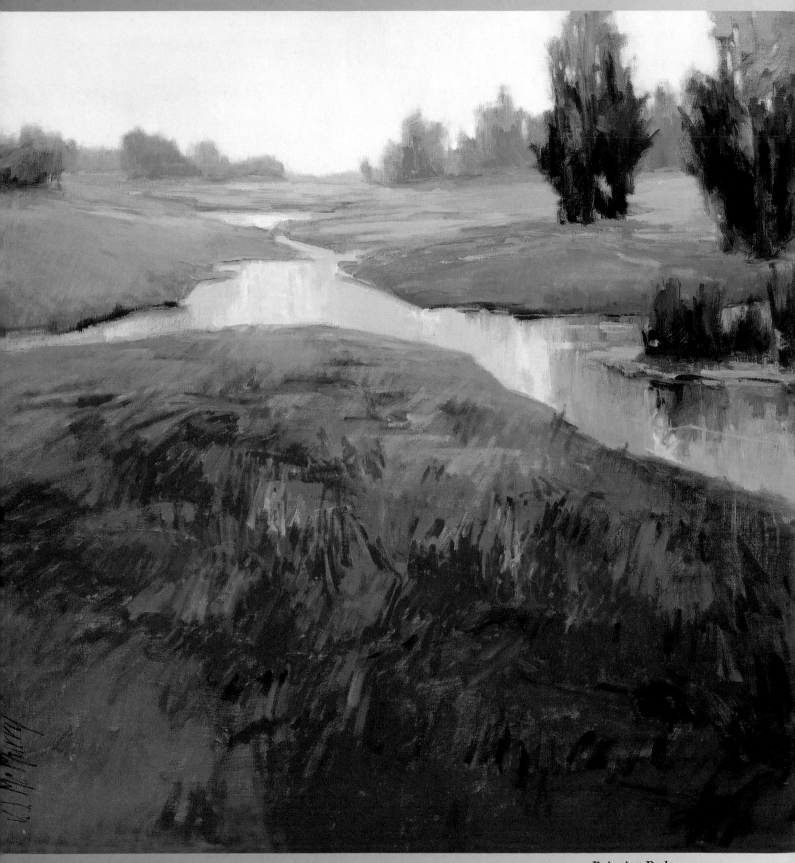

**Reigning Reds**
30" × 30" (76cm × 76cm)
Collection of Vicki Oswalt

# Mastering Color

## The Essentials of Color Illustrated With Oils

Vicki McMurry

**NORTH LIGHT BOOKS**
CINCINNATI, OHIO
www.artistsnetwork.com

## About the Author

Vicki McMurry sees life and her surroundings with a deep appreciation for the smallest pleasures. She adds color and light to her images in unexpected places, fueling sparks of heartfelt emotion. Vicki's unique vision stems from a childhood in east Texas, a locale she remembers as devoid of color and differentiation. She daydreamed of hills, tall trees and blue water.

She embarked on her oil painting career in 1988, studying under well-known artists. As an oil painter, she has won awards and been published in the *Artist's Magazine*, *Decor* magazine and *Southwest Art* magazine. In addition to being featured in galleries, her work is published by Canadian Art Prints, Winn Devon Art Group and Open Air Designs. Her corporate collectors include the University of Texas; Club Corp of America; the City of Austin, Texas; and Sid Peterson Memorial Hospital. Her work is also featured on her website, www.vickimcmurry.com.

She is recognized for her landscapes of depth, harmony and balance. Emotionally charged, she brings life and joy to every stroke of the brush. Her expression gracefully combines Impressionism, Expressionism and abstractionism. "I want society to see and feel the beauty that I feel."

She stays "on message," determined to reach her potential. "One lifetime is a blink. Leaving a legacy is a long, unveiling journey of the hidden nuances that fill our hearts. There is still much to learn and experience and little time in a blink."

**Mastering Color: The Essentials of Color Illustrated With Oils**. Copyright © 2006 by Vicki McMurry. Manufactured in China. All rights reserved. No part of this book may be reproduced in any form or by any electronic or mechanical means including information storage and retrieval systems without permission in writing from the publisher, except by a reviewer who may quote brief passages in a review. Published by North Light Books, an imprint of F+W Publications, Inc., 4700 East Galbraith Road, Cincinnati, Ohio 45236. (800) 289-0963. First Edition.

Other fine North Light Books are available from your local bookstore, art supply store or direct from the publisher.

10  09  08  07  06     5  4  3  2  1

DISTRIBUTED IN CANADA BY FRASER DIRECT
100 Armstrong Avenue
Georgetown, ON, Canada L7G 5S4
Tel: (905) 877-4411

DISTRIBUTED IN THE U.K. AND EUROPE BY DAVID & CHARLES
Brunel House, Newton Abbot, Devon, TQ12 4PU, England
Tel: (+44) 1626 323200, Fax: (+44) 1626 323319
Email: mail@davidandcharles.co.uk

DISTRIBUTED IN AUSTRALIA BY CAPRICORN LINK
P.O. Box 704, S. Windsor NSW, 2756 Australia
Tel: (02) 4577-3555

**Library of Congress Cataloging in Publication Data**
McMurry, Vicki
  Mastering color : the essentials of color illustrated with oils / Vicki McMurry.-- 1st ed.
    p. cm.
  ISBN 1-58180-635-3 (hardcover : alk. paper)
  1. Color in art. 2. Painting--Technique. I. Title.
  ND1488.M35 2006
  751.45--dc22                          2005015100

Edited by Vanessa Lyman
Design and production art by Lisa Holstein
Cover designed by Matt Strippelhoff/Red Hawk Creative
Production coordinated by Mark Griffin

## Metric Conversion Chart

| To convert | to | multiply by |
| --- | --- | --- |
| Inches | Centimeters | 2.54 |
| Centimeters | Inches | 0.4 |
| Feet | Centimeters | 30.5 |
| Centimeters | Feet | 0.03 |
| Yards | Meters | 0.9 |
| Meters | Yards | 1.1 |
| Sq. Inches | Sq. Centimeters | 6.45 |
| Sq. Centimeters | Sq. Inches | 0.16 |
| Sq. Feet | Sq. Meters | 0.09 |
| Sq. Meters | Sq. Feet | 10.8 |
| Sq. Yards | Sq. Meters | 0.8 |
| Sq. Meters | Sq. Yards | 1.2 |

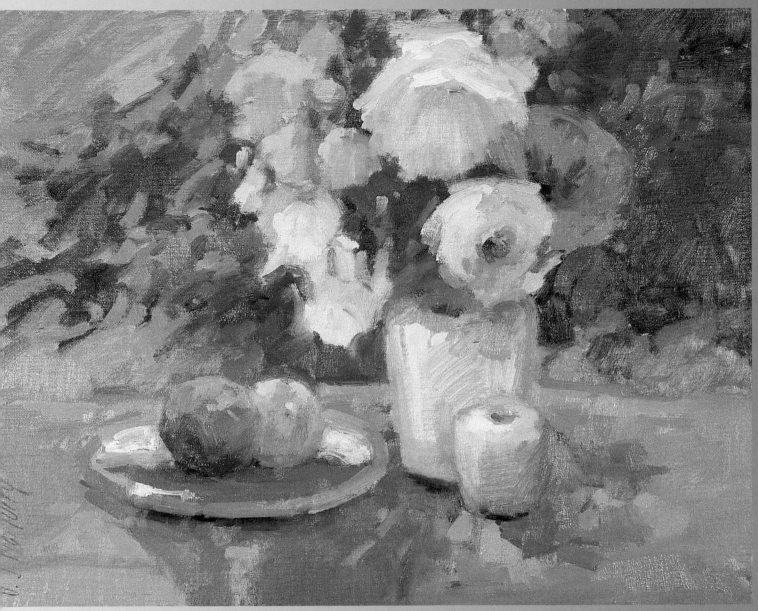

**Delicate Light**
14" × 18" (36cm × 46cm)

## Acknowledgments

I'm most grateful to my editors, Rachel Wolf and Vanessa Lyman. I want to thank Rachel for recognizing my potential and encouraging me to write a book about color. Vanessa endured my creative ups and downs with grace, understanding and a mind open to new approaches. Rachel and Vanessa have made this a rewarding and pleasant experience.

Thanks also go to Jeff Rowe, Dundee Murray and Brian Morrison for their wonderful photography.

To all of my teachers, thank you for sharing your knowledge and for your words of encouragement. The road to success is arduous, but I cherish the glimmers of hope you gave me along the way.

To my late brother, Jeffrey John Yudin, I hope that you are watching from above with pride. You accepted me as I am, protected me from harm and showed me how to find the path to achievement. It has taken me a while to accept my own accomplishments.

To all of my friends and collectors, thank you for supporting my creative soul and career. I never would have made it this far without each and every one of you.

## Dedication

I dedicate this book to my daughter, Margo Delaine McMurry. Being a full-time house-keeper, mother, wife, volunteer and painter would wear me down, but Delaine pumped me up with encouragement and sent me back to work full of clarity and hope. We have shared so much together, and I admire her. When I grow up, I'd like to be just like her.

Introduction 9

**Serenity**
30" × 30" (76cm × 76cm)
Collection of Kent, Carol and Clara Fancher

# Introduction

Close your eyes and imagine a world without color. How would we interpret beauty? We'd need to rely on smell, sound and touch for emotional responses. I've sat through movies in which the director intentionally avoided color to establish a bleak atmosphere. Although the director achieved his goal, I left feeling emotionally disturbed. Could I live like that? The answer is yes, if I had to. But I would rather enjoy the emotions of color. Color adds a great deal of joy to my life.

In this book, I share my responses to color and ask you to examine yours. I also demonstrate various approaches to mixing color and show you how to design with color in mind.

Color is a tool too powerful to ignore. Our response to color is immediate and visceral. Advertisers have known this for years and pour millions of dollars into researching it. The right colors will encourage us to buy a product, but the wrong colors will turn us off completely. Why not incorporate this phenomenon into your work? You can create powerful paintings that appeal to your viewers on a gut level if you make the exact right color choice. And with over a million colors identified, there's an enormous range to choose from.

The Pantone Color Institute researches color trends. Many companies follow the Pantone color guide when introducing their new products each year. As tempting as it may be to incorporate this year's best-selling blue into your paintings, as an artist you are obligated to look beyond the trends. Following trends will limit your expression, and shorten the life span of work. Masterpieces survive because they incorporate overarching color truths, not just trends. It's one thing to incorporate blue into a painting to generate a positive, peaceful reaction and another to match the latest fabrics and linoleum.

Personal response will ultimately define your expression in the truest form. How you experience color—your preferences and dislikes, for example—stems from your deep-seated memories, as well as how you feel about yourself and your surroundings. Using color *honestly* will blend your subject with you and your viewer in a very personal and heartfelt manner.

I continually search for hidden colors in subjects. The subtle colors are often the most exciting, depending on the surrounding color family. I want to add sparkle whenever and wherever possible. I will push a color warmer, cooler or richer just because I can. I am in control and empowered. This is the artistic license I relish.

Throughout this book, you'll be examining color closely and examining your responses to it even more closely.

## Color Choice

I begin every commission by viewing the space where the painting will be displayed. By taking in the essence of the space, I get a better sense of the collectors. In this case, I responded to the lighthearted and serene aspect of the space. The colors and lighting in the room were soft and cool. I knew I would draw from that while painting, maybe using a few slightly more intense colors. The couple, both avid sailors, selected a boat photograph from my trip to Italy as the subject. I was delighted; it fit so well with the feel of the room. I allowed the mood of the space to control the painting. By doing this, *Serenity* became an effortless creation.

# Paint and the Palette

*Turning an artist loose in an art store is like turning a child loose in a candy store. Buying new equipment or a new tube of paint is exhilarating, but in time, you'll accumulate a closetful of unused supplies. I wish I could spare you the expense and disappointment, but trial and error seems to be the best lesson in life and art.*

*Every painting in this book was created with a <u>nine-color palette</u> (with a few exceptions for some demonstrations). Having only nine colors on your palette might seem confining, but even a mathematician couldn't begin to calculate all the possibilities offered by these nine colors. Every day, I create or discover another new color or a new color scheme. Eliminate all but the bare necessities, and let yourself have the freedom necessary to create.*

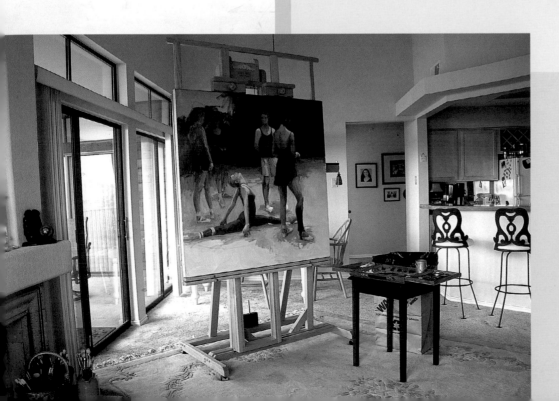

# Oil Painting Materials

I have an overly active brain, so I like to keep things in my life simple, including art supplies and equipment. After many years of experimentation, I've narrowed down my preferences to the the items listed in these pages. Any creative endeavor entails some struggle, but there's no need to add the frustration of inadequate or poor-quality supplies.

In large part, your development as an artist comes though experimentation, which often leads to accidental—and frequently thrilling—discoveries. I encourage you to experiment with this in mind.

## Oil Paints

I don't mind working hard and long hours. I *do* mind inconsistent paint quality or stiff paint. The price range of oil paints on the market varies. Quality is my first consideration, then the price. Gamblin Oil Colors and Classic Artist Oils both have the consistency of whipped butter. I can use these paints "as is," without adding linseed oil to obtain the desired soft texture. Classic Artist Oils offers Titanium White by the quart. Because Titanium White is a slow drying white, I add a small amount of Winsor & Newton's Griffin Alkyd Flake White to speed the drying process. This is the only altering I do to my paints.

## Palette

After our cat jumped onto my palette, I purchased a French Companion or Mistress, a palette case that I can leave open as I paint. I can close it at night to keep my paints soft and keep the cat out of the paint while I am away from the easel.

On top of my palette, I lay a piece of paper and then a piece of glass. The glass is a fine surface for the paint. You can adjust the color of the paper under the glass depending on your needs. Some artists like to use a midtone gray for the paper. It helps them judge the correct values.

Small palettes may inhibit the amount of paint you squeeze onto the palette. The good news is that the mixing room is limited and forces the paints into each other. Larger palettes are preferred by avid paint slingers who squeeze larger amounts of paint onto the palette.

## Paint Scraper and Palette Knife

As my palette gets filled with mixtures of paint, I will scrape the paint together with a palette knife and make room for new mixtures. I pile the scraped paint and use it for creating grays. These piles are unique in character. I cherish them as the ultimate mother colors (see page 54).

At the end of the day, I scrape the paint from the palette with a razor blade and rub the surface with a tissue.

## Paper Towels, Tissues and Trash Bags

I use paper towels for wiping the paint from brushes. Tissues are good for removing paint from the scraper and wiping the surface of the palette. Large brown lawn bags lined with plastic lawn bags make disposal easy.

## Studio Easel

A few years ago, I finally splurged on a Hughes Easel. Painting immediately became easier. This easel holds large canvases. The frame has a pulley system, so maneuvering canvases side to side and up and down is effortless. I can also set up two canvases on the easel simultaneously.

## Brushes

Some artists use several brushes as they paint, one for each color family or for certain details and shapes. Other than the "sketching brush" that I use at the beginning, I'm notorious for using the same brush through the entire painting. Generally, I match the brush size to the canvas size. Brush nos. 4 and 6 are good for 14" × 18" (36cm × 46cm) canvases and smaller. Brush nos. 8, 10 and 12 are good for 24" × 30" (61cm × 76cm) and larger. A no. 2 brush is excellent for sketching and detailing.

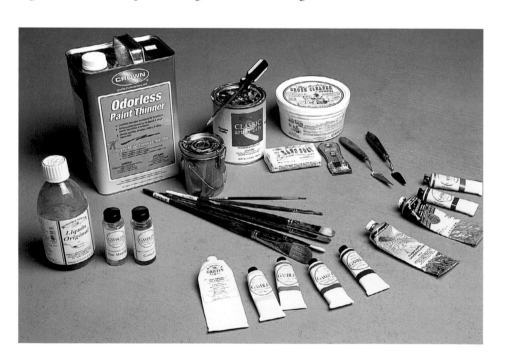

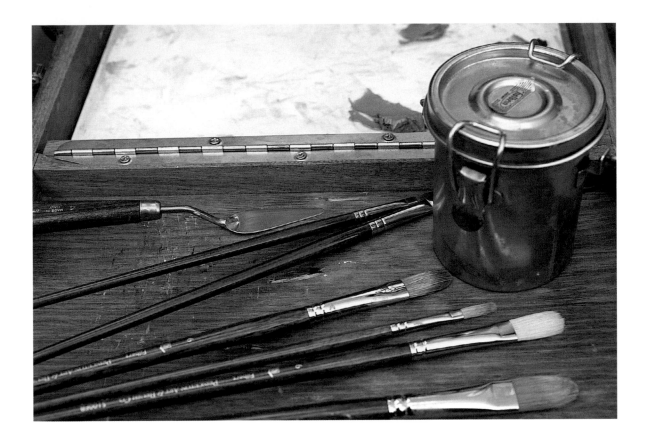

Brushes have a flat side that we use most often. The thin edge of a brush is very effective for detailing without changing brushes.

I use nos. 2, 4, 6, 8, 10 and 12 filbert hog bristle brushes by Princeton or Grumbacher. These are ideal inexpensive brushes for oil painting. I prefer the more expensive sable brushes for portrait painting. A no. 1 round sable liner brush is handy for signing paintings (I sign with a color used in the painting and thinned with turpentine).

## Turpentine

Turpentine tins have rubber seals and latches. They don't leak, and they secure the turpentine well. Odorless turpentine is recommended. Gamblin Artists Colors provides Gamsol, an odorless and less harmful solvent.

## Lighting

Over the years, I have painted with a variety of artificial and natural lighting. At one time, my studio was a 10' × 10' (3m × 3m) bedroom with southern light exposure. This lighting was sporadic. I continually had to re-key the values in a painting. I would also have to haul the paintings outdoors to get a true reading of the values. A room with northern exposure to natural light is superior (at least in the northern hemisphere). This light is more constant and provides additional hours of painting each day.

## Care of Brushes

I overheard a student say that she learned not to dip her brush in turpentine after watching me paint. I wasn't aware of my habits until it was brought to my attention. The majority of the time, I simply swipe my brush between layers of paper towel before picking up a fresh color. I always wipe the brush prior to cleaning it with turpentine. As a result, my brushes last longer and my turpentine stays cleaner.

About once a month, I clean my brushes with Master's Brush Cleaner and Preserver if the bristles are not worn down. The bristles on new brushes are longer and more flexible. I use the worn brushes for toning and varnishing. My brushes rarely get stiff with paint build-up mainly because I pick up lots of paint on the tips only. I don't scrub or mash paint, which works paint deep into the bristles.

You should use Master's Brush Cleaner and Preserver as directed, but I have to confess that I've used this product to perform miracles. I've used it to lift red permanent marker from hardwood floors, to unstick paper plates fused to the dining room table with melted nacho cheese, to remove paint from oriental rugs, and even to clean my daughter's cat after he jumped on my palette.

# Brush Grips

I studied violin as a child, and it turned out to be a good background for fine art. I grip my brush in my fingertips much the way I was taught to hold my violin bow.

When I paint, I stand so that I can use my entire body to paint (sitting, although sometimes necessary, stifles expressive brushwork). I hold the brush in front of me as if I'm conducting an orchestra. This way, the brush becomes an extension of my arm. I want my work to express an underlining feeling of rhythm, loud and soft, fast and slow.

Let your brushwork be the musical notes that resonate visually. Find those resonating notes. Portray them.

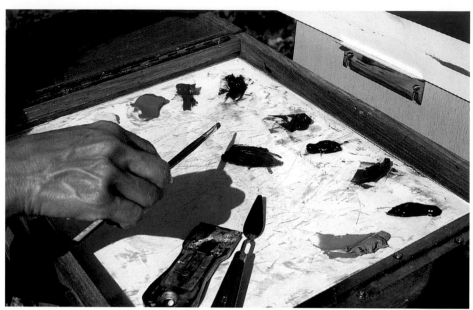

### The "Picking-Up" Grip

Our natural instinct is to hold a brush like we hold pencils or pens, but this method restricts movement to the wrist and fingers. I suggest gripping the brush similar to the grip we use to pick up a pencil or pen. Now the entire arm is free to move.

### Pile It On

Pick up enough paint on the tip of the brush to cover a significant area on the canvas.

### Music and Art

One time, I was listening to Madonna's "La Isla Bonita" while I was painting. I became enamored with the music and found myself dancing and painting. I would dance backwards some six feet and then dance my way back to the easel. As realization of my behavior crept in, I hoped that no one was looking. I sure had a good time. It's fun to tap into the unconditioned child within.

We will paint to the rhythm of the music we listen to while painting. The slower the music, the slower we will paint. The faster the music, the faster we will paint. (I prefer fast!) I enjoy the results of intuitive painting and looser brushwork.

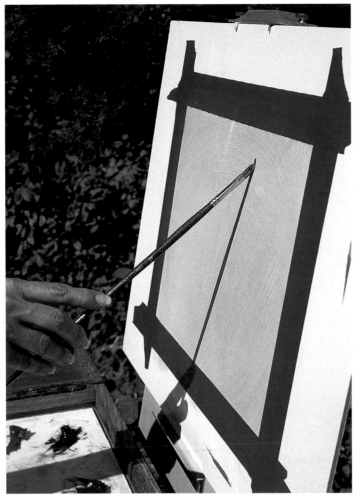

## Delicate Grips

I grip at the end of the handle for sketching and delicate maneuvers or details.

## Intense Grips

I gradually inch my way toward the bristles as I begin applying paint to larger areas. I avoid getting too close to the bristles to prevent mashing the paint onto the canvas. Mashing thins the paint too much and has a tendency to muddy the colors. Mashing also lifts more paint off the canvas than it leaves behind. I want enough paint on the canvas to blend colors into each other.

# Stretch Your Own Canvas

By stretching your own canvases, you make all sizes immediately available, and you can use a canvas you know you like. Since I use ready-toned canvas, I'm also able to start painting without further preparation.

I use Kent linen canvases and Fredrix stretcher bars. The regular-weight stretcher bars work well for sizes 24" × 30" (61cm × 76cm) and smaller. I use medium-weight stretcher bars plus a cross bar for larger sizes. The light-weight bars can't handle the tension of significant width; the bars tend to bow inward.

The Kent single primed linen does not have as much elasticity as cotton duck canvas. It needs to be stretched tight enough to override humid atmospheres. I ping the canvas with my finger and listen for a certain musical note to judge the tautness of the canvas. I want my brush to bounce off of the canvas surface as I paint.

If you have trouble stretching linen, try cotton duck. It has more elasticity, and the weather is not a major factor. I use linen strictly for the texture. The smoother the texture, the easier it is for me to move the paint around the canvas. There is less drag on my brush, which speeds my painting application. Consider using portrait-grade cotton duck canvas as an alternative to linen.

## Stretching Materials

- Linen canvas
- Stretcher bars
- Measuring tape
- Hammer
- Scissors
- Staple gun
- Compressor
- Canvas pliers

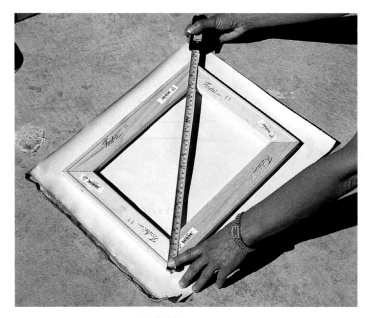

### 1 Establish the Format

Hammer the stretcher bars together. Measure cross corners for equal lengths. This determines if the right angles at corners are correct. Accuracy is important for fitting the canvas with a frame later on. If the measurements are equal, staple three times at the joints on the flat edges. This secures any movement of the stretchers during the stretching process.

Lay the framework on the canvas and cut, allowing 2" (5cm) of canvas beyond the bars for gripping and wrapping.

### 2 Staple the Canvas

Begin stapling the canvas to the bars according to the diagram. The diagram indicates the easiest way to avoid puckering and produces a taut canvas. My staples are approximately 2½" (6cm) apart.

### 3 Complete the Process

Miter the corners and staple securely. Miter on the length bars. It's easier to eliminate any puckering that may occur along the shorter width. Don't cut surplus canvas; you may need it for re-stretching or resizing. Wrap surplus canvas to the back side of stretchers and staple minimally.

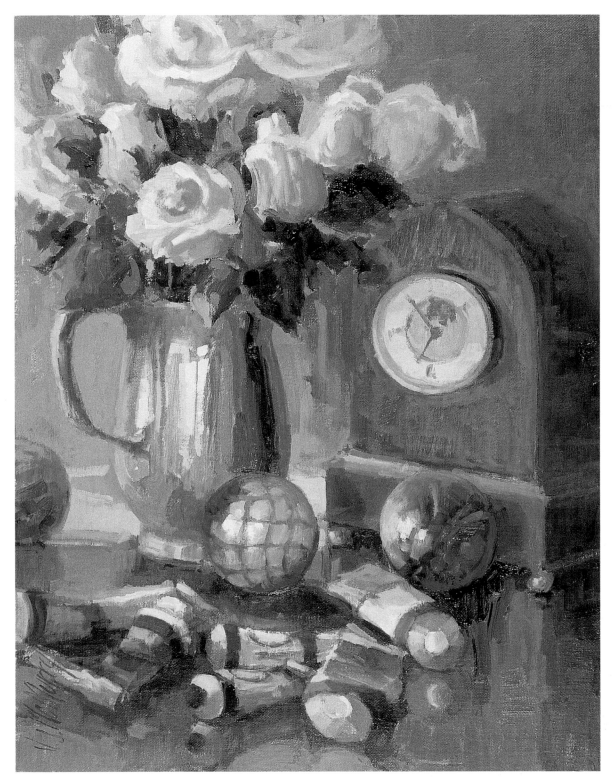

Treasures for artist are time, beautiful subjects, and art supplies. I have said often that time is my worst enemy. That may be true for all artists. Is there enough time in life to learn all the creative fundamentals? In my search for the perfect painting, I need to let go of that anxiety caused by the ticking clock. I do, however, pause long enough to smell the flowers, and then paint them. Tubes of paint are my cherished tools (or toys) and represent the same joy and anticipation as presents on holidays.

**My Treasures**
18" × 14" (46cm × 36cm)

# The Palette

My palette of eight colors (plus Titanium White) is based on value range, color intensity or luminosity, and temperature. As for brands, I prefer Classic Artist Oils or Gamblin Oil Colors.

- Cadmium Yellow Light has a very light natural value, an appealing luminosity and moderate pigmentation. It leans toward being cool.

- Cadmium Orange has a naturally light value, appealing luminosity and moderate pigmentation. It can be warm or neutral.

- Cadmium Red Light is a middle value, and has appealing luminosity and moderate pigmentation, and it's warm.

- Alizarin Crimson has a darker value, appealing luminosity and strong pigmentation. It's a cool color.

- Quinacridone Violet has a darker value, appealing luminosity, strong pigmentation and is warm.

- Platinum Violet has a darker value, appealing luminosity and very strong pigmentation and it's cool.

- Ultramarine Blue has a darker value, low luminosity and moderate pigmentation, and it's warm.

- Phthalo Green has a dark value, appealing luminosity and very strong pigmentation, and it's cool.

You might notice that I prefer colors with an appealing luminosity. I have a workable balance of temperatures and pigmentation, and I also have a full range of values (Cadmium Yellow Light being the lightest and Phthalo Green being the darkest). I believe that it's better to work with clean, pure pigments and mix these colors together for the varying degrees of each color and the gray tones.

## Arranging Your Palette

You can arrange colors on your palette in a number of ways, from lightest to darkest, according to temperature, even according to your favorite to least favorite color. Whichever arrangement you choose, I encourage you to keep it consistent. Once you determine the next step in a painting, you can proceed quickly if the pigment is in a familiar location. I've included several possible arrangements to consider.

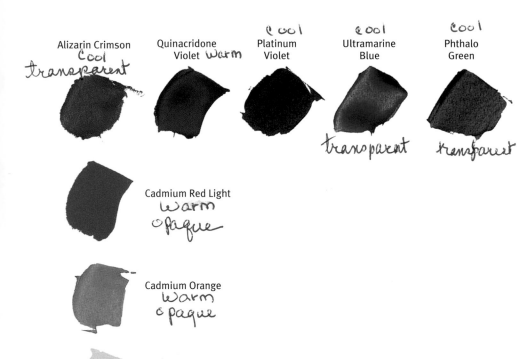

Alizarin Crimson — *Cool* — *transparent*
Quinacridone Violet — *Warm*
Platinum Violet — *cool*
Ultramarine Blue — *cool* — *transparent*
Phthalo Green — *cool* — *transparent*

Cadmium Red Light — *warm* — *opaque*

Cadmium Orange — *warm* — *opaque*

Cadmium Yellow Light — *cool* — *opaque*

*My Basic Palette*

I use a simple palette of eight colors (plus Titanium White) arranged to more or less follow the color spectrum. I also arrange the reds and purples with the warm pigment followed by the cool pigment. I've used this palette consistently for years. I can mix virtually any color. Occasionally, I add another color at the end of the spectrum and isolate it. I may be bored or decide to explore a different color as a mother color. If you're like me and have bags of abandoned paint, choosing one as a mother color is a great way to make use of them.

## Additional Colors

I use only a few paints that I know well. My theory is that if I can make a color, I don't need it on the palette. For example, to get Cadmium Yellow Medium, I can combine Cadmium Yellow Light with Cadmium Orange, so I generally keep it off my palette. After all, why take up space?

Nonetheless, throughout this book, I mention colors that aren't on the palette shown here. Here is a list of those colors:

- Indian Yellow
- Venetian Red
- Cobalt Blue
- Cerulean Blue
- Phthalo Blue
- Sap Green

It can be fun to experiment and get to know other colors.

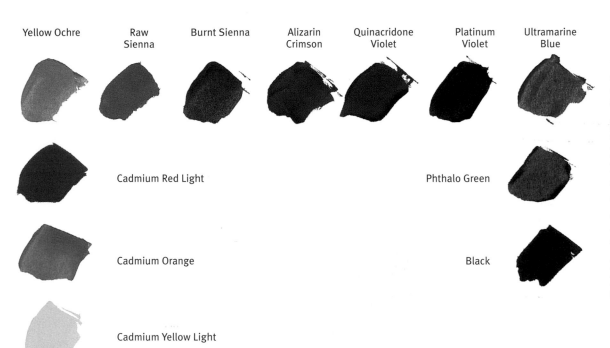

Yellow Ochre    Raw Sienna    Burnt Sienna    Alizarin Crimson    Quinacridone Violet    Platinum Violet    Ultramarine Blue

Cadmium Red Light

Cadmium Orange

Cadmium Yellow Light

Phthalo Green

Black

### Earth Tone Palette

On this palette, the earth colors are placed as a sidebar. This is my basic palette plus Yellow Ochre, Raw Sienna, Burnt Sienna and Black. I've arranged them according to value, the lightest color is the Cadmium Yellow Light. Titanium White, part of my basic palette, doesn't appear here.

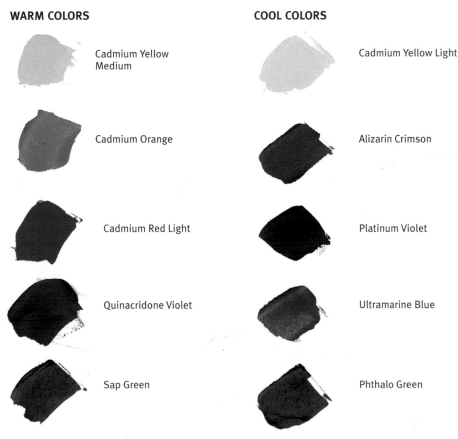

**WARM COLORS**

Cadmium Yellow Medium

Cadmium Orange

Cadmium Red Light

Quinacridone Violet

Sap Green

**COOL COLORS**

Cadmium Yellow Light

Alizarin Crimson

Platinum Violet

Ultramarine Blue

Phthalo Green

### Temperature Palette

This is a good layout while developing temperature theories. Keep some white available for tinting.

### Learn to Mix

Imagine that you're painting on location and you forgot to pack a particular tube of paint. Or maybe you're painting late at night and run out of a color you need. These situations are frustrating. Learn how to adapt: mix the missing color, or let the situation be an open door to new discoveries. Mistakes and new discoveries are my most cherished painting moments. They force me to grow.

# Color Density

One property of color is density. Colors can be divided into two categories, transparent or opaque.

## Transparent Colors

Transparent colors appear clear like stained glass and are useful for creating transparent masses and a sense of weightlessness. They also have strong pigmentation and staining power, which may overwhelm a novice painter. Their pigmentation is more permanent than that of opaque colors and will leave a stain when removed. They are known to bleed through top layers of paint over time. Transparent colors are useful for glazing over a dry painting because they can add subtle color without covering the paint beneath them. You can change the overall color, temperature or value by glazing.

## Opaque Colors

If transparent colors are stained glass, opaque colors are milk glass. The opaque pigments create masses that completely cover the underlayers when applied thickly, but they can also create a sense of fogginess when scumbled in a thin layer over a dry painting.

Each of these properties creates a different psychological effect. If you paint an overcast day, you would choose Cadmium Red (opaque) instead of Alizarin Crimson (transparent) to alter your sky mixture and create the same illusion of the density created naturally by the atmosphere. For a clear day free of moisture and pollution, choose transparent colors.

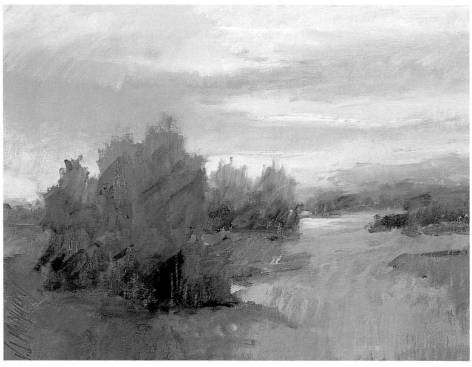

*Use Density for Special Effects*
*A Warm Welcome* is painted entirely opaquely. The sky, ground and trees all have density. Psychologically, this creates a moody, pensive atmosphere. The colors are primarily warm. While adding final details to the painting, I accented the dark side of the tree with a transparent mixture to add a little interest to the otherwise opaque painting.

**A Warm Welcome**
14" × 18" (36cm × 46cm)

### Divided by Density

**Transparent**
Indian Yellow, Transparent Orange, Alizarin Crimson, Ultramarine Blue, Sap Green and Phthalo Green

**Opaque**
Titanium White, Cadmium Yellow, Cadmium Orange, Cadmium Red Light, Cobalt Blue, Cerulean Blue, Emerald Green and Phthalo Yellow Green

# Working With Density

The masters painted their transparent darks thinly. As they painted into the light areas, their paint became thicker. Thick over thin was the rule at the time. Now, the application of paints seems irrelevant. Your expression is far more important. Try the following ways to apply transparent and opaque colors. If you can, use the same image for each approach. Make a note of your favorite method.

## Combine Opaque and Transparent Paints

To truly capture the attention of your audience, avoid a fifty-fifty distribution of opaque and transparent paints. Experiment with a variety of combinations. Try

- All transparent colors
- Some transparent areas and some opaque areas
- Opaque pigment painted into the wet transparent washes
- Transparent pigment over wet opaque areas for color and intensity
- A transparent glaze over a dry painting
- An opaque layer scumbled over a dry painting

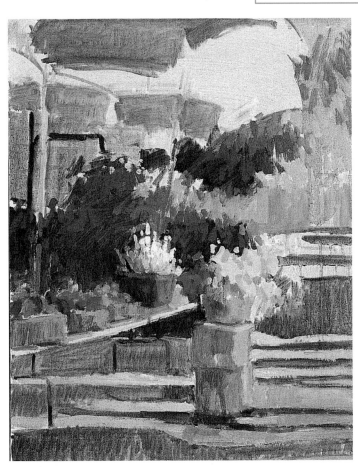

### Underpainting

In *Morning Market*, I chose to use thin washes of the transparent colors to block in the painting, which is a common approach to beginning a painting. Specifically, I want my darks to be luminous, and the transparent pigments let the lighter undertone show through. I left areas blank where I would be applying opaque colors or adding Titanium White to color mixtures.

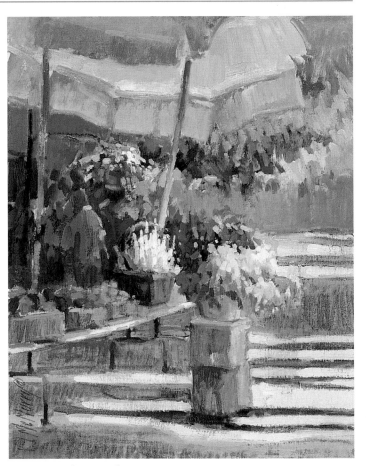

### Opaque Light Areas

I finished by painting the middle-value and light areas with the opaque colors. If your transparent underpainting is still wet, you can blend it with the opaque colors effectively. I left some of the original transparent colors untouched to add depth and variety to the painting. Because opaque colors are normally daubed on in thick layers and transparent colors are applied in thin washes, the combination of the two on one painting adds texture and depth.

**Morning Market**
18" × 14" (46cm × 36cm)
Collection of Margo Delaine McMurry

# Paint Applications

There are two methods, indirect and direct, for applying oil paints to surfaces. Within these methods, there are variations. Often, it's our personality that determines which approach we use, and there's nothing wrong with that, but it's good to change our method of paint application once in a while to trigger new self-awareness.

I recommend exploring both techniques from the beginning to find which suits you best. One method may seem confining while the other may seem liberating; maybe a combination of methods seems easiest. Your experiences will ultimately guide your decision.

I use a combination of direct and indirect painting. I may be patient in many areas of life, but I paint very fast and look forward to the next painting. I don't possess the patience needed for solely indirect painting.

My personal goal is to paint each painting *alla prima*, which is painting directly in one session. If a painting gets off course, I let it dry and then apply a thin wash (glaze or scumble) to pull it together. Glazing or scumbling also works to adjust value or temperature in isolated spots in a painting. Thus, I rely on direct and indirect applications of paint.

## Wet Brush or Drybrush

"Wet brush" implies that the brush is wet with turpentine or medium. This will somewhat thin the paints. I use wet brush in the first stage of painting or if I am glazing or scumbling. 'Drybrush' means wiping a brush dry before picking up paint. I drybrush to apply thicker paint. At times, I drybrush for scumbling.

Manufacturers and artists have developed a multitude of mediums and combinations of mediums. Although each medium on the market has a basic purpose, you can dilute and combine several to create your own unique medium.

*Thin Layers*

**Glazing** is the use of transparent colors diluted with turpentine and applied thinly. **Scumbling** is the use of opaque colors mixed with turpentine and applied thinly.

*Painting With a Palette Knife*
If you are paint shy, try palette knife painting to become accustomed to piling on the paint. You can always work the paint with a brush if so desired. I embellished *Soup Can* with a few brushstrokes.

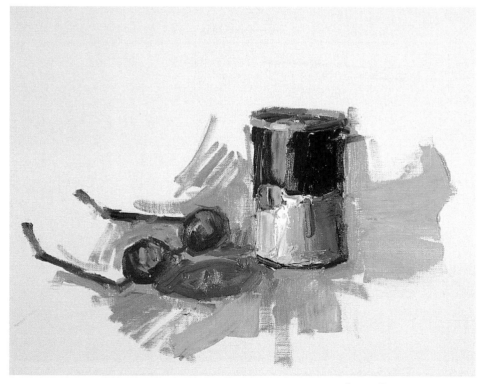

**Soup Can**
9" × 12" (23cm × 30cm)

# Indirect Painting

Indirect painting involves laying down an underpainting of local color and then building up the color by glazing or scumbling several layers with a wet brush.

Applying dark transparent colors during the first applications defines subtle darks. Applying opaque colors during the initial application and then subsequently glazing with transparent colors adds luster.

Indirect painting involves some forethought, patience, and time. Trying this method as least once is beneficial. As a result, you will understand the principle of glazing and scumbling.

## The Masters

The Old Masters applied thin washes of local colors as the first step. The next steps involved applying additional washes of tones (colors combined with black) and tints (colors combined with white).

### 1 Apply Local Colors

For the first step, I applied local colors to the masses that I would develop. The color was very flat at this point.

### 2 Add Tints and Tones

I enhanced the tints and tones and began suggesting the water's surface at this point.

### 3 Add Surface Layer

Here, I glazed the entire painting with Ultramarine Blue for the water surface. This pushed the fish beneath the surface of the water. I began to create the water ripples.

### 4 Finalize Details

I used turpentine to glaze the painting one more time to push the fish farther beneath the water's surface. I enhanced the ripple design by adding warmer color notes to bond the warm notes of the fish.

**Swimming in Circles**
11" × 14" (28cm × 36cm)

# Direct Painting

Direct painting can be approached in several ways. You can mix colors prior to application, or you can block in the darks and then proceed to mix various values and temperatures into and with the darks on the palette.

Generally, I use the block-in method. Occasionally, I pre-mix a few colors if I am having trouble focusing. Drybrush and wet brush are used in direct painting.

The wetter the brush, the more you can slip and slide colors into each other on the canvas. Use a light hand and a little pressure to drybrush the lights and middle values over the darks.

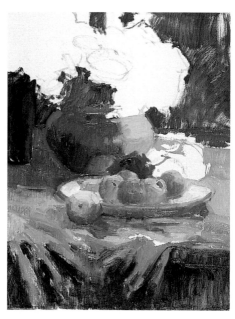

### 1 Begin With Dark Values

I did not tone this canvas prior to painting. I had a lazy lapse. After I sketched the design on the canvas, I began blocking in the dark areas of the painting. I kept the values close intentionally so that I could manipulate the value differences later as the painting developed.

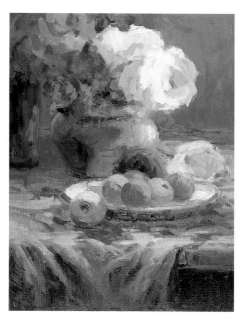

### 2 Continue Blocking In

I determined that the design was working, so I continued blocking in the middle and light values. I worked pure pigments and grays back and forth.

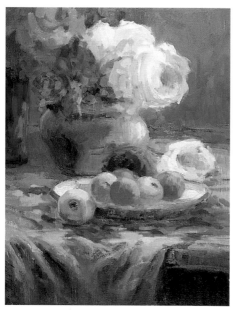

### 3 Finalize and Complete

I darkened and lightened a few values as needed. I introduced additional middle values, especially amongst the flowers. I added some luminosity by using purer pigments in the "light."

*A Rich Moment* took three attempts of direct painting to complete. I used drybrush for the entire painting.

**A Rich Moment**
18" × 14" (46cm × 36cm)

# Painting Directly Alla Prima

Painting alla prima—or painting directly all in one sitting—captures the excitement and freshness of the inspirational moment. A comprehensive knowledge of design, value and temperature is helpful for alla prima painting.

When you are able to paint alla prima, be proud of yourself. This accomplishment means that you have acquired the necessary skills to make correct decisions from the onset to the completion of a painting.

## Variations of Direct Painting

You can vary your approach to direct painting in many ways:

- Paint wet into wet (applying wet paint into and onto wet paint).
- Paint wet over dry (apply wet paint over dry paint).
- Paint pure pigments over grayed pigments.
- Paint grayed pigments over pure pigments.
- Alternate pure and grayed pigments.

### Alla Prima Keeps Work Fresh

*Bridling Balloons* is an alla prima painting. The chalky background gray was a concern until I popped the light on the boys' shoulders. This light worked without detracting from the saturated color of the balloons. The chalky background color also depicts the harsh summer light well. I feel comfortable leaving the painting in this pristine stage.

**Bridling Balloons**
14" × 11" (36cm × 28cm)

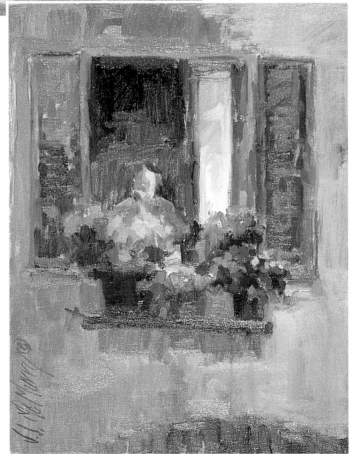

### Keep it Simple

It's far easier to paint alla prima if the image is simple and the canvas size is small. I am enamored with paintings that capture a person in a poignant moment. Is the woman at the window restless, bored, tired of her duties or just curious?

Once I had rendered the woman and the surrounding darks, I had enough paint to scrape together for a nice mud. I used this mud to paint the building. Thus, I was able to paint *Window to the World* in one session.

**Window to the World**
12" × 9" (30cm × 23cm)

# Painting En Plein Air

This book is about color, and light is the essence of color. The best way to learn about the interplay of light and color is to experience it, often and at various times of the day. Photographs do not do justice to landscapes: The darks are too dark and the lights are too light. The smells and sounds in nature are intoxicating and relay their essences into outdoor painting. Plein air painting is by far the basic method of learning the truth about the land, which benefits all subjects. Once you have learned about light, color and color temperatures in nature, you will process the same information into the rest of your work.

Once, I came home from painting from dawn to dusk once to hear my family tease me about having a day off. Tired, dirty, hungry and needing the comforts of home, I questioned my own sanity. Now, I realize that I have memorized the light and am able to incorporate this knowledge throughout my work. Is it worth it? Yes. Think about our predecessors. They lacked modern conveniences and good artificial lighting. It was natural for them to go outdoors to paint, not only for the light and to learn about the light, but also to seek out subjects.

## Portable Plein Air Painting Equipment

I do have a lazy side to my character. When painting en plein air, I want my equipment to be portable and accessible. In other words, I want to make only one trip from the car to the chosen painting location. I am also a small person, so I avoid heavy or cumbersome equipment.

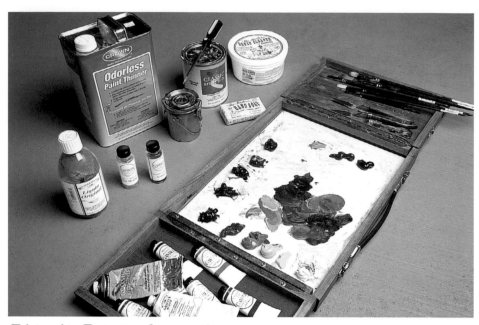

*Plein Air Painting Materials*
When you strip them down to the bare essentials, you can easily carry all of your oil painting supplies with you while you scout a location.

*Backpack*
The easel, paints, brushes, palette knives, razor, paper towels, bungee and camera all fit nicely in a backpack. This leaves your hands and arms free for toting the tripod. This is my favorite method for toting equipment.

## Easel

I began my plein air painting trips with a French easel. They are clever inventions. My French easel endured a lot of abuse before it finally splintered in my luggage on a flight. If this is your choice for an easel, you will need pliers to tighten the nuts when setting up. At a Plein Air Painters of America event, my easel crashed in the middle of a painting. I hadn't tightened the nut on one of the legs properly. To make matters worse, I had thrown my back out retrieving my luggage from the conveyor belt the day before. I gingerly recovered the easel and palette. My shoes were covered with Alizarin Crimson before everything was upright and ready to go again.

After that disaster, I moved on to the Open Box M easel. It is definitely lightweight and portable with few fragile parts, but I prefer painting larger canvases when I'm on location than an Open Box M can handle. This easel should be anchored with something sturdy on a windy day.

Now, I have an EasyL easel which accommodates larger canvases. I also like the height of the palette and its proximity to the canvas; it's similar to the arrangement I have in the studio.

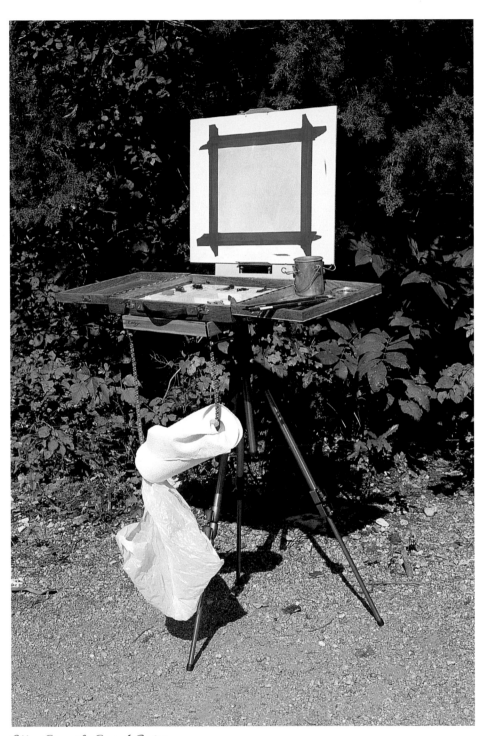

*My EasyL Easel Setup*
I hang paper towels and a grocery sack on a bungee hooked to the easel. This easel comes with hooks to hang the turpentine can if more palette space is desired.

For plein air painting, I pre-cut canvases 4" (10cm) larger than standard sizes. Instead of cutting a canvas to be 8" × 10" (20cm × 25cm), I would cut it to be 12" × 14" (30cm × 36cm). I carry two 16" × 20" (41cm × 51cm) panels on location. Using painter's tape, I pre-tape canvases to the front and back of each panel. For transporting wet canvases, I cover each with waxed paper. I remove the paper as soon as possible. I don't worry about smashing the paint. These paintings usually require touch-ups anyway.

I have traveled overseas with thirty canvases pre-cut and rolled inside my suitcase. They can also be packed flat between the boards. I used to glue canvas to boards, but that was time consuming, expensive and cumbersome. My method gives me the freedom to stretch the good paintings and discard the bad without regrets. I also use scrap canvas taped to boards in the studio for studies.

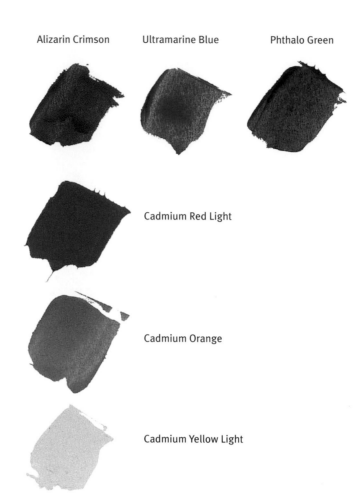

Alizarin Crimson   Ultramarine Blue   Phthalo Green

Cadmium Red Light

Cadmium Orange

Cadmium Yellow Light

### Plein Air Palette

You should really eliminate excess weight and simplify your palette for plein air painting. The limited palette shown here gives you a stretchable range of colors and values. Titanium White should also have a place on your plein air palette, though it is not shown here.

Remember that you are limited to an hour of painting before the light changes. You don't want an excessive number of choices slowing your momentum. A limited palette will also readily yield color harmony.

## Helpful Hints

- Before painting, take a photograph to use later as a reference.
- Keep equipment simple. The weather and environment can be difficult.
- Bring pre-moistened wipes to remove paint and turpentine from hands.
- Paint early or late in the day for the best light (and to escape the heat).
- Paint with other people if possible. It's nice to receive help if accidents occur.
- Try painting without a viewfinder. A viewfinder may hamper a complete view of an enormous sky. I usually incorporate more of the sky than the land in my paintings. I do this intentionally. Psychologically, the sky represents no boundaries to me—a key element in my paintings.

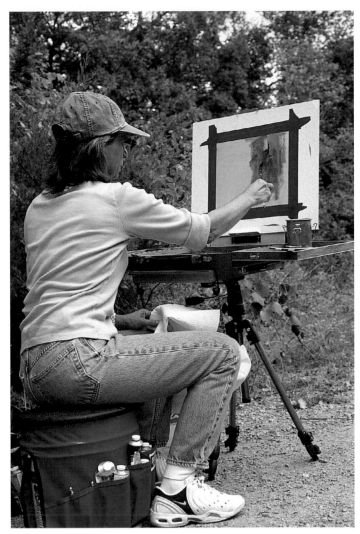

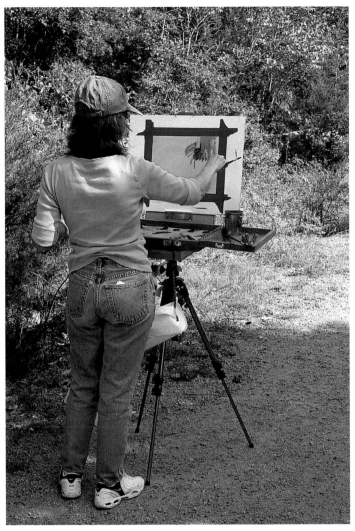

*Set Up in the Shade*

Be sure to find a shady area that will remain shady for approximately 1-1½ hours. I stopped using an umbrella long ago. They are additional baggage and become a nuisance in the wind. If there's no shade available, turn the easel so that the canvas and palette block the sun.

*Need to Sit?*

Five-gallon paint buckets with aprons and lids hold paints, brushes, turpentine tins, palette knives and razors efficiently. They can be used as chairs if need be.

## The Terrors of Plein Air Painting

On one plein air excursion, I was roaming a ranch for a scene to paint. I found a good location, got out of the car and opened the trunk to retrieve my gear. I heard a loud moo in the distance and glanced up to see a herd of grazing cows looking at me and my red sweatshirt.

They started trotting toward me.

I tensed up instantly. I am definitely citified, and I thought that the herd was going to charge me because I was wearing red. By the time I ripped the sweatshirt off, they had surrounded me. It was then that I realized they probably thought I carried food pellets in my trunk, just like the rancher. The red sweatshirt was irrelevant.

Relieved—and a little embarrassed—I proceeded to cautiously set up and paint. One of the cows remained inches from my palette during the entire painting. She seemed determined to sample the oil paints.

# Color Relationships

*Every creation has a beginning. The same holds true for creating a unique palette for you. We'll start with the primary colors—yellow, red, blue—and include white and black. We will progressively build a palette, ending with the earth tones. Along the way, you will adopt your favorites and lose the undesirables. Your favorites will include the colors that support your identity and are manageable. The undesirables will include colors that you are unable to control and with which you feel no kinship. The palette you ultimately create for yourself is like a thumbprint: It's uniquely yours.*

*Life is unpredictable and loaded with changes. Thus, your palette will change along with you.*

**A Scintillating Sunset**
24" × 30" (61cm × 76cm)
Collection of Tyra and J. Kinney Kane

# Examine Your Color Response

There's no doubt that responses to and interpretation of color are strongly individual. Whether negative or positive, we associate experiences with color and color with experiences. Different emotions will surface when you see different colors.

The sooner we identify our reactions to color, the sooner we can meet our potential as visual artists. How would you describe a color? Does it seem aloof or welcoming? Pensive? Bold? There are many descriptive terms to apply to color.

These interpretations are entirely personal. I love the color blue, but only for decorative accents, clothes or cars. A room painted blue makes me feel cold, uncomfortable and restless. I like warm yellow because I associate it with the sun and warmth. I like cool yellow because it reminds me of lemons. I enjoy the smell and taste.

There are very few colors that I do not like. However, there are several colors that I feel I can't use in a saturated way at

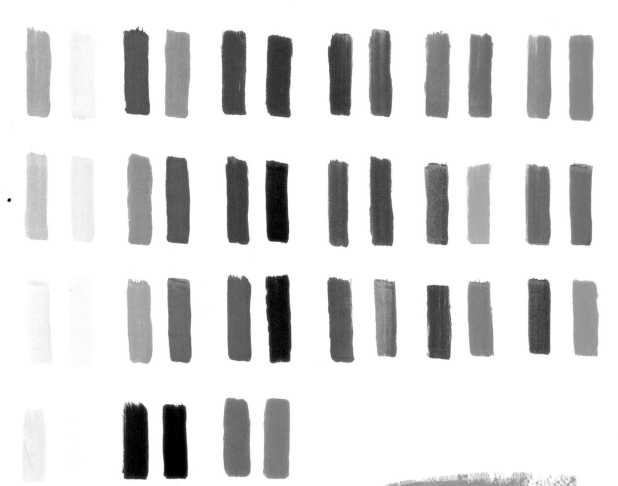

## Color

This chart might help you discover whether you have a favorite color family. Build a body of work using these families. If you need to be challenged, adopt new color families for a time and build a new body of work.

## Color Preference—Written on the Skin?

My absolutely favorite colors seem to match my skin tones. I have olive skin, hazel eyes and warm brown hair. Everything is warm, and I automatically gravitate to the warm version of each color. I have noticed fellow artists painting with the cool versions of the colors that match their skin tones. In choosing decorative accents or clothing, I've noticed that people in general—not just artists—choose colors that match or react well with their skin tones. Knowing this, when someone commissions a painting, I try to work in the patron's skin tones, and any supporting colors.

this time. Life goes on and changes, so I may embrace these colors at some point as new experiences influence me and the negative impressions disintegrate.

Most artists seem to go through a "color period" at some point in their careers. Any color period usually stems from an emotional frame of mind. I've gone through a blue period with my work and also, more recently, a red period. Was it anger, passion, excitement, rebellion or nervous energy that led me to paint red? Probably all of the above. All I could do was paint red until this phase passed. I used this opportunity to explore red since my emotional self was urging me. Red was the last color for me to explore. Now that I have, I've moved on to embrace the whole color wheel. Open up your self expression with color.

## Aspects of Color

Every color has qualities that can be described in terms of hue, temperature, value and saturation. These qualities can work in harmony or in contrast, they can work in balance or in dominance. In a painting, neighboring colors of different temperatures add sparkle, or visual excitement, to paintings. Brilliant colors placed side by side will compete for dominance. Much like two people constantly fighting, it's not very fun. But finding sparkle in the middle of the mud is exciting!

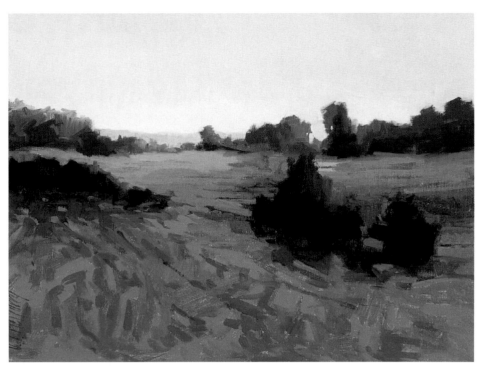

*Listening to Your Mood*
*Gold Glints* is an excellent example of employing moods rather than rules. This painting borders on Expressionism. When I painted this, I had never seen a landscape with this color family. Not only that, but I broke the rules by putting the warm colors in the background and the cool colors in the foreground. I let my mood take charge and waited for the surprise ending. The painting sold right away.

**Gold Glints**
14" × 18" (36cm × 46cm)

## Beyond Emotion

We all see color differently, and that perception goes beyond the emotional aspect. A few years ago, I had eye surgery in which my natural lens was replaced with an artificial lens. The doctor said that I would see color better. I laughed because I already saw vivid color, but sure enough, color appeared brighter and crisper after the surgery. Until that point, I assumed that we all saw color alike. Now I know better.

# Hue: The Color Wheel

The success or failure of a painting's color scheme is determined by the source colors and temperature. To understand the source colors, you need to know each color's relationship to the others. The color wheel is a way to visualize these relationships.

## Primary Colors

The primary colors are yellow, red and blue. These three colors are the basic source colors for all other colors. Similar to buildings or structures, colors need foundations and primary colors are your building blocks.

Every color has one or more primary colors in it. However you mix a color, it will always lean toward one of the primaries. A purple will lean toward blue or red, and a green will be more yellow or blue. This has an effect on your composition, so pay attention to which primary colors are dominant in your mixtures.

I've read that products with all three primary colors outsell products without yellow, red and blue. I had to find out for myself if the theory was true, so I tried it in a few paintings to see if they would sell. They're selling. Does this mean I'll always include the three primaries in my paintings? Probably not; the paintings where I listen to my mood sell the best of all.

## Secondary Colors

The secondary colors are orange, purple and green. Each one is created by mixing two of the primary colors together: red and blue will yield purple, red and yellow yield orange, and blue and yellow yield green. This is just the beginning of an enormous array of color mixtures.

With secondary colors, we encounter complementary colors. Complementary colors are opposing colors on the color wheel. A primary color has a secondary color as its complement. The secondary purple, for example, is the complement of the primary yellow. Purple has no yellow in it, but it does have the two other primaries—red and blue. Because purple and yellow are opposites, they can accentuate each other brilliantly when placed side by side in a painting. The other sets of complementary colors are red/green and blue/orange.

By combining a complementary pair, you'll get a gray. This is the beginning of multiplying a color into an endless range of various values and temperatures. The excitement of mixing colors by this method never seems to end.

## Tertiary Colors

The tertiary colors (also called intermediary colors) are created when you mix a primary color with one of its secondary colors. The secondary color already has a little of the primary in it, so adding more of the primary can really energize the color and push it in a particular direction. The tertiary colors are yellow-orange, red-orange, red-violet, blue-violet, yellow-green and blue-green. (Notice how the primary color comes first in the color's name.) With the tertiary colors, you really move into the exploration of temperature.

*Hue*

The hue is the name of the color: yellow, yellow-green, green, blue-green, etc. It's one of the first qualities of color we recognize and name.

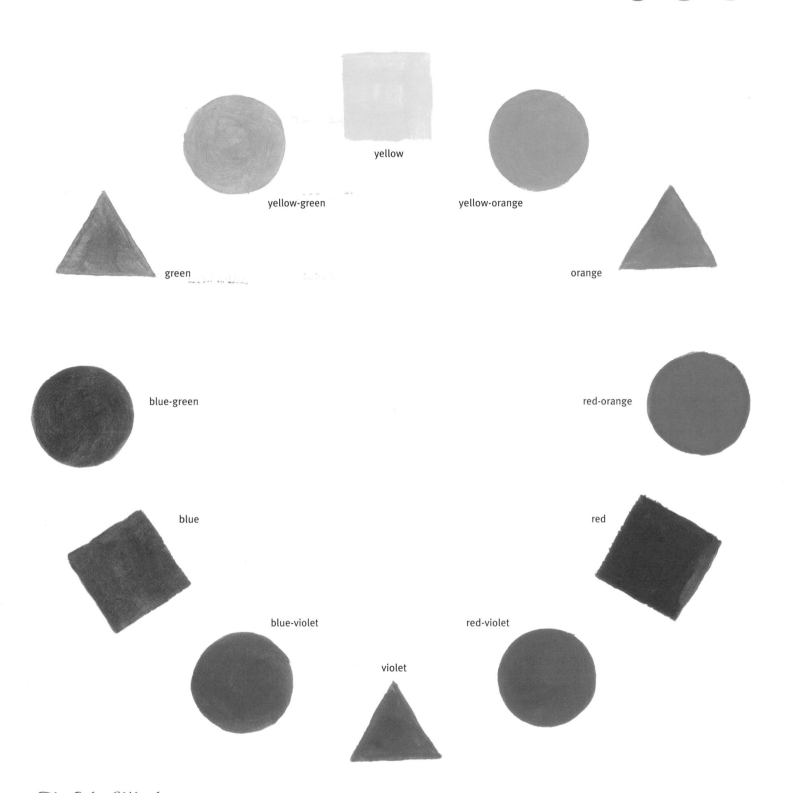

yellow

yellow-green

yellow-orange

green

orange

blue-green

red-orange

blue

red

blue-violet

red-violet

violet

## The Color Wheel

This color wheel uses color placement and shape to show the relationship between hues. The primary colors are in blocks because they're the building blocks of all other colors. The secondary colors are in triangles, which is the shape associated with change and movement. The tertiary colors are circles because they're harmonizing with their neighbors—no sharp edges. Each primary color (square) is directly across from the secondary color (triangle) that is its complement.

# Temperature

The temperature of a color within a painting is determined by its inherent temperature (whether it leans warm or cool in its original state) and by any adjacent color.

A common selection of primaries is Cadmium Yellow Medium, Cadmium Red Light and Cobalt Blue. For my primary colors, I favor Cadmium Yellow Light (a cool yellow), Cadmium Red Light (a warm red) and Ultramarine Blue (a warm blue). This means one cool primary and two warm primaries. (If I want a cooler painting, I make a point of dominating the painting with cooler hues.)

Regardless of which paints you select as your primary colors, mix them to to create the secondary and tertiary colors to see the effects. By experimenting with the primaries this way, you'll see how your basic colors develop into relationships.

Temperature has a huge effect on the viewer. It's one of the main characteristics of a color that we respond to. The truth is that I like some temperatures in the color spectrum, but not all. Dark, cold blues make me shiver and withdraw. They remind me of the depths of water, which I fear. I will use dark, muddy blues sparingly. I'm definitely drawn to the warmer colors.

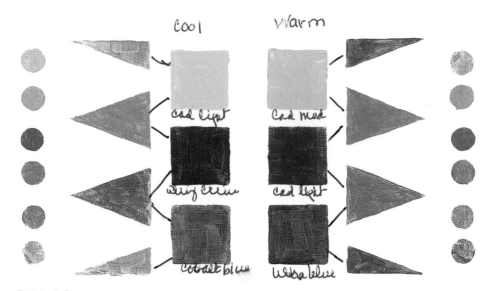

*Think Temperature*

This chart shows the three primary colors extended into warm and cool mixtures.

On the right are the warm primary colors: Cadmium Yellow Medium, Cadmium Red Light and Ultramarine Blue. I mixed these colors together for the secondary colors (the triangles) and tertiary colors (the circles). There's enough yellow in Cadmium Red Light that when it's mixed with Ultramarine Blue a muddy purple is created. The red in Ultramarine Blue results in a muddy green when it's combined with Cadmium Yellow Light.

On the left are the cool primary colors: Cadmium Yellow Light, Alizarin Crimson and Cobalt Blue. Again, I mixed these primaries together for the secondary colors (the triangles) and tertiary colors (the circles). The orange appears bluish in this instance because the Alizarin Crimson leans toward blue.

*Contrast of Temperature*

In this painting there are a variety of color relationships at work, but it's the contrast of temperature that really arrests the viewer's attention. In this otherwise warm painting, the viewer's eye seeks the relief of that cool blue streak in the water and then lingers there.

**Tapestry Treasure**
40" × 40" (102cm × 102cm)

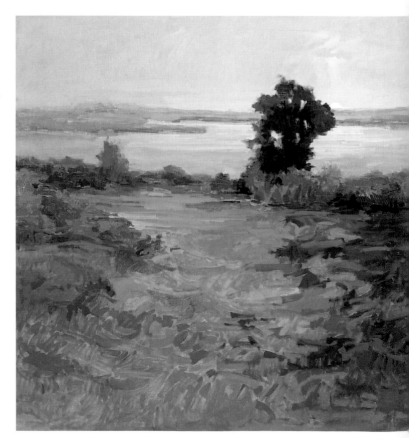

When standing alone, colors have an inherent temperature. Normally, we consider yellows, oranges and reds to be warm. Purples, blues and greens are considered to be cool. A color's neighbors can influence the temperature, too. Purple, for example, will seem warm in an otherwise cool painting. From this paragraph on, begin thinking of a color's temperature in terms of its neighbor.

If you think of each brushstroke in terms of temperature, you'll simplify your next choices. If you use temperature to create contrast or unity, you'll know precisely what color to pick; likewise with dominance or balance. For the next stroke, I think about temperature and value before I think of color. If I allow my thoughts to focus on color first, I will overlook precisely what makes color sing: temperature and value.

The easiest method for developing temperature skills is to paint what you see, looking intensely. Think of water. Naturally, we think cool temperature. Closer examination reveals both cool temperatures and warm temperatures. The water may be reflecting warm light from a nearby building. The land underneath the surface of the water may be warm compared to the cool blue reflection of the sky. Virtually everything we see will include both warm and cool color temperatures.

One key to your success is identifying the correct temperature of each plane. Think temperature first and value second. The lighting of the subject will balance the temperatures automatically. The lighting tells the story and determines the message.

Alternating between cool and warm colors throughout a painting adds energy and sparkle. I enjoy alternating temperatures; from a distance, the painting looks peaceful, but there's still a great deal of excitement.

**Top Row**: Look close at these three so-called cool colors. The green and blue appear cool next to the purple, which now appears warm. When you compare them to the streak of cooler violet across the bottom, all three cool colors appear warm.

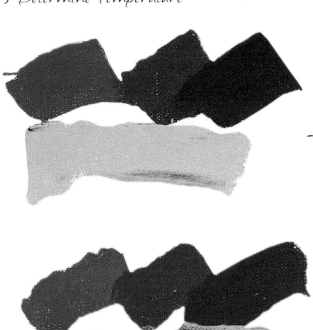

**Middle Row**: I used the same three cool colors as above. The streak of warm, light orange below forces these colors toward blue, which is cool.

**Bottom Row**: I scraped all of the colors together—including the warm, light orange and cooler violet—and ended up with this fabulous yellow-leaning khaki. I used this "mud" to make a new green, blue and violet. The blue leans warm compared to the green, but leans cool compared to the khaki. The violet leans cool (bluish) compared to the khaki, and leans warm (reddish) compared to the blue.

## Depth by Temperature

For large, undeveloped areas, keep in mind that warm colors come forward while cool colors recede. This can be useful when creating depth.

# Value

I joke that trying to learn color value just about ended my art career. I didn't think that I was ever going to "get it." In fact, I'm still working on it!

Broken down to the most basic definition, value is the lightness or darkness of a color. All color has a value. Yellow, for example, has a naturally light value. Blue tends to be naturally darker in value.

When I first started learning about value, I fought this idea. One teacher warned me that yellow should not be placed in a dark area of a painting because of its naturally light value. I brushed this advice aside and did it anyway. Wrong. The painting never succeeded because I simply did not understand value and how to use it.

Value only really "clicked" for me when a teacher told me to simplify a landscape painting into four planes: one light, two middle value and one dark. I began to simplify, finally letting go of the traditional ten degree value scale chart altogether. This worked so well that I now think in terms of just four values: light, light middle, dark middle and dark.

## Ways to See Value

One well-known method for seeing value is to squint at the subject. This process somewhat eliminates the middle values and emphasizes the light and dark values. Squinting also helps reveal the overall value composition.

Another option is to use a transparent sheet of red acetate (you can pick these up at most office supply stores) to observe the values. Viewed through the red acetate, a color's other qualities (temperature, saturation, hue) will be subdued so you can focus on value alone. I use the red acetate for a quick check. If I'm still doubtful, I'll use my digital camera on the black-and-white setting to view the subject.

Paint manufacturers often print the value of each color right on the paint tube, but I usually ignore this. I'll buy a color simply because I love it. I then proceed to play with it to see what it can do.

## Adjusting Value

You can take a color up or down the value scale by adjusting it. A *tint* is a color lightened with white or another light value, like Cadmium Yellow Light. White paints can make a color's brilliance dull and chalky. It's much better to "come up the

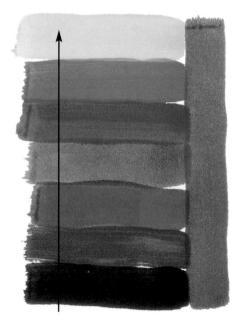

color wheel" (see below). A *shade* is a color darkened with black or another dark value, like Burnt Umber.

Another way to adjust a color's value is through placement. I learned that from another workshop teacher, who recommended that I mix and judge the correct values according to the adjacent color's value. Placing a darker middle value next to a light value makes the middle value

### *Revaluing Red*

This color swatch shows six values of Cadmium Red Light; the darkest value is at the bottom and the lightest value is at the top. I worked my way up to the lightest value by adding more and more Titanium White. Notice how the Alizarin Crimson on the right is naturally darker than the darkest value of Cadmium Red Light? Alizarin Crimson would need far more Titanium White to match that lightest value of Cadmium Red Light.

### *Coming Up the Color Wheel*

Titanium White is usually the lightest value on a palette, but you should use it cautiously. Adding it to colors can dull the luminosity of the color.

What do I mean by "coming up the color wheel"? Let's say you want to lighten Cadmium Red Light. Mixing Cadmium Orange (a naturally lighter value) will help lighten the value of Cadmium Red Light. If that mixture still isn't light enough, adding Cadmium Yellow Light (an even lighter value) may work. Only after this should you add white. This process almost guarantees to vibrant colors.

seem very dark, but when you place it next to a dark value, it'll appear lighter.

The key to successfully using value is to introduce the correct values in the first place, which I refer to as "keying in the values." In high-key painting, all of the values tend to be on the light side. A low-key painting relies on darker values to establish the mood. In general, I like to include a range of values.

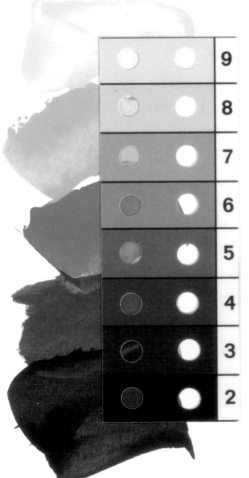

### Value and Design
Have unequal proportions of value in your composition to avoid repetition. Let one value dominate.

### A Brushful of Color
Is your palette too far away from the painting for you to determine if your mixture works for a particular spot? Try holding a brushful of the mixed color next to the spot on the painting. This should help you judge the temperature and value.

### A Value Scale
This shows five values of Cadmium Orange. The manufactured value scale only goes from two to nine; ten would be pure white and one would be solid black.

# Saturation

Saturation is the intensity or purity of a color. A muted or grayed color has low saturation. A brilliant, unadulterated color has high saturation. There are three ways to desaturate or gray a color: Add its complement, mix a warm with a cool, or add black.

Early in my career, I almost exclusively used bright, highly saturated color. I had negative emotional reactions to grays and darker, more subdued pigments. These hues were so depressing to me that I avoided them. During this period, I was intensely happy. I had found stability in marriage, and I cherished being a mother. To add to this good fortune, I was painting.

In the midst of this, my brother passed away. His death hit me hard. I abandoned art altogether for about six months. Spending time with my family became far more important. Art seemed selfish at the time.

After some time passed, I received a phone call that pulled me back into art. The art guild for our local museum requested that I paint the poster for their annual fund-raising event. Though I hadn't painted in some time, the opportunity was simply to good to decline. I quickly said yes.

Some sort of change usually results from traumatic events. It wasn't until I started painting for this event that I understood how my personal experience would alter my approach to art. Starting with the fund-raising poster, I felt an urgent need to explore a wider field of

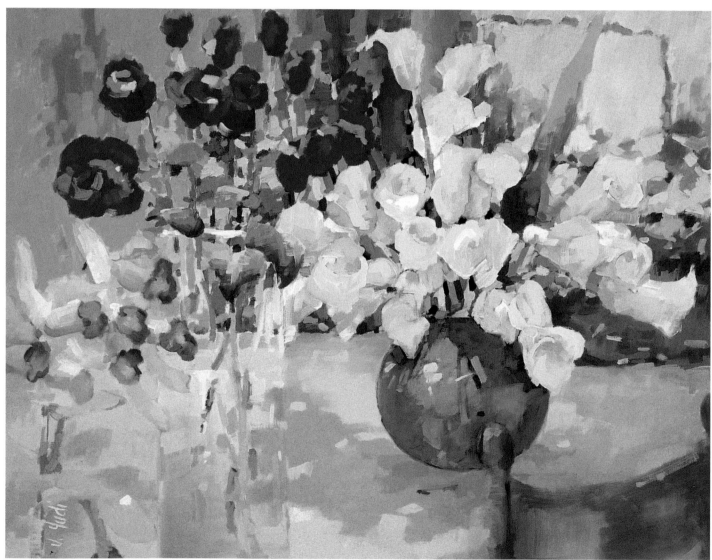

*Highly Saturated Color*
When I dug these images out of my archives, my initial response to them was simply, Wow. Was I really that happy? My style has definitely changed. If I chose to try this style again, I'll undoubtedly find myself incorporating all the knowledge I've gained. The real question is whether or not I can recapture the emotional state in which I created this highly saturated, pulsating image.

**Sunny Sparks of Color**
22" × 28" (56cm × 71cm)

colors. I have learned to appreciate and admire the grays. They offer pleasant, ongoing surprises with each painting. If handled appropriately, the colors with low saturation can be the magical elements that make the other colors shine their brightest.

You're not required to paint with low-intensity colors. Successful artists frequently use highly saturated color for their paintings; it's a perfectly valid and attractive style of expression. Because there is no way to predict or dictate the future, the path of least resistance is to paint the depth of your feelings at any given time. Your color style will be born of that. Your life dictates expression; let it happen.

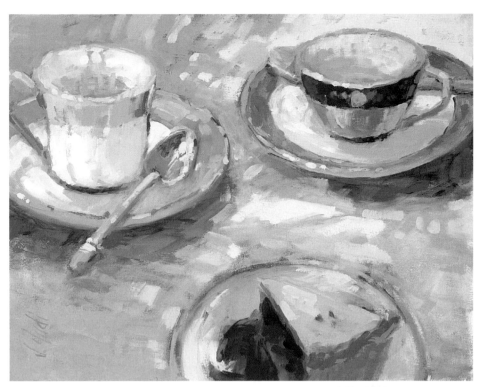

**The Visit**
11" × 14" (28cm × 36cm)

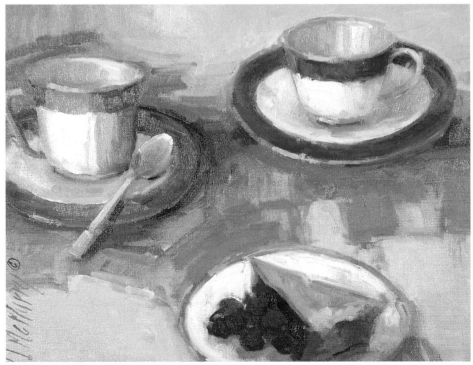

**The Moment**
11" × 14" (28cm × 36cm)

### Grays Do Make a Difference
Years ago, before I learned about painting with grays, I painted *The Visit*. I painted *The Moment* to demonstrate the variation in colors and the illusion of depth that gray offers. If you think that you aren't making progress, try revisiting an old painting and paint an updated version to test your skills.

*The arrangement in these two paintings is risky: There are three objects, none overlap and two are on the edge. To keep the viewer's eye in the painting, I linked the cups with an abstract pattern of color.*

### Pure Attraction
We're attracted to pure, highly saturated color—especially when it's surrounded by grays—so try to use it at your center of interest.

41

# Manifesting the Mood

Because color is the first visual stimulus our brains interpret, the mood of a painting depends on color. Even subject matter is subordinate to color in creating mood.

Artists can control subject matter, design and technique. We can *try* to control expressive mood, but controlling mood is like swimming against the current: It's far easier to let mood be in control. This method also gives a truer meaning to the overall expression of a painting.

I spend a few moments preparing my palette before painting; this preparation time pulls my energies into a playful creative mode. I pick up a brush to begin painting and let it hover over the palette. I let instinct guide my brush to the color that best expresses my current mood.

I might select a color that I have ignored lately or that I need to explore more, but my mood ultimately makes the decision for me. If I need pampering, I'll relax with one of my favorite colors. If I am energized, I'll explore new combinations of colors.

Trying to control color and mood to garner more sales is useless. Every color will be interpreted differently by individuals. Yellow may represent a sunny day and happiness for some, while others see yellow as a cowardly color. Because there is no way to determine or predict a viewer's interpretation of color, let your own interpretation prevail. If you feel unusually passionate, select colors like red and purple. You'll be fulfilling a mood that needs to speak.

### Somber
This painting is dominated by dark values. The mood is certainly on the depressed, even weary, end of the mood scale. The toothbrushes suggest dreary mundane routine.

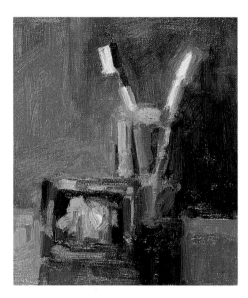

### Sweet
The warm, light values in this painting are somewhat sweet. The rosy dawnlike colors are hopeful and kind. Is the house still quiet before the kids wake up?

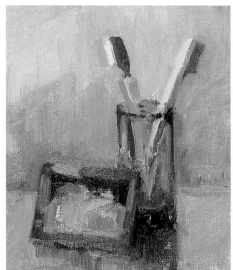

### Calm
The cool blues that dominate this painting are steady and calm. The coolness of the painting with the subject matter suggest a fresh new day, full of many possibilities—just as soon as you brush your teeth.

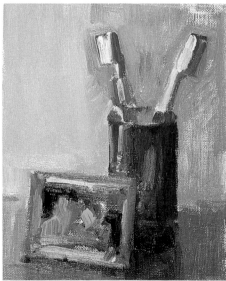

### Happy
The saturated colors here are more cheerful than the other studies. The yellow and blue dominate he picture. This reliance on the two primary colors, tempered only a little with other pigments, makes the scene seem happy, confident and straightforward.

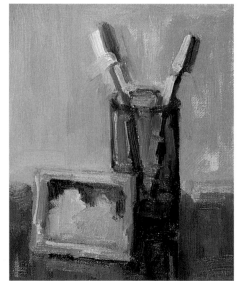

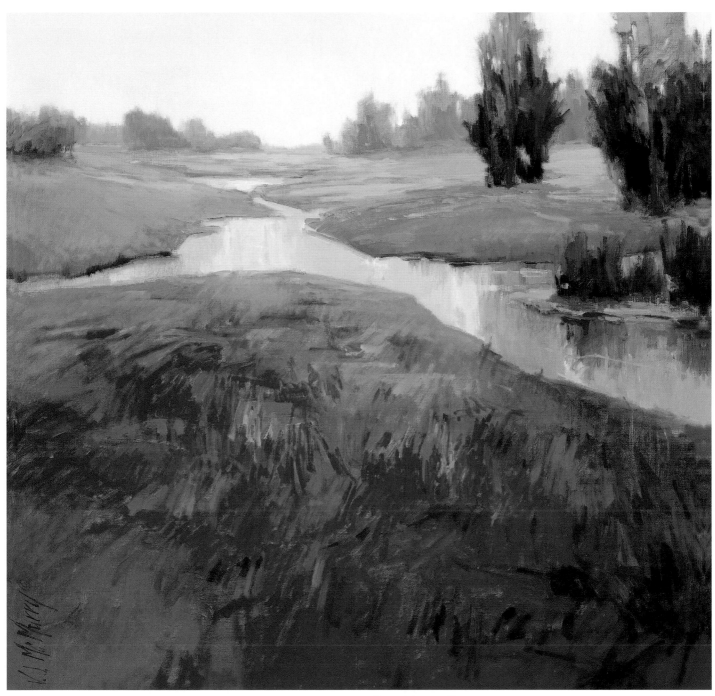

*The intense, highly saturated reds attract more attention than the muted grays ever could. To keep the painting balanced, I allowed the grays to have more coverage. The grays dominate by space, and the reds dominate by intensity.*

## Combining Moods

The reds in the foreground portray high energy and passion. The muted grays receding to the background calm the painting. The cooler grays tame the intense reds. If I had covered more of the canvas with the fire engine reds, this piece may have been too intense for some people to enjoy; creating both moods in one painting holds our interest in the painting longer. The expression is not too intense in either direction of the mood scale; instead, it is subtle.

**Reigning Reds**
30" × 30" (76cm × 76cm)
Collection of Vicki Oswalt

# Establishing the Right Mood

To establish the right mood, you're going to find yourself relying on value, temperature and saturation.

For this painting, I chose a purple-hued wash of Ultramarine Blue + Alizarin Crimson to tone the canvas. This grayed base tone creates a mood that's pensive, quiet and maybe a little tense, very much like the swamp I was depicting. Neither warm nor cool, this wash worked well with both the land and sky and captured the overcast quality of the day.

A good undercoat is important. It will harmonize by appearing throughout the painting in the "unpainted spaces" (between brushstrokes, for example). Because it appears between brushstrokes and under glazes, an undercoat has a powerful effect on the mood of the painting. Choose your undercoat carefully.

## Colors Used

Titanium White
Cadmium Yellow Light
Cadmium Orange
Alizarin Crimson
Platinum Violet
Ultramarine Blue
Phthalo Green

### 1 Exaggerate the Mood

My reference photograph revealed that the water was decidedly warm while the land, trees and sky were cool on this overcast day, so I toned my canvas with a cooler mixture of Ultramarine Blue + Alizarin Crimson. Then I mixed both a warm version and a cool version of the mother color, a combination of Alizarin Crimson + Phthalo Green. I used the cool version for the land and the warm version to mix colors for the water.

The tree trunk helps to pull the warmth above the horizon line and unites the two distinct areas.

The abstract patterns of light and dark in the water draw the viewer's attention to this part of the landscape, which is the area I initially intended to generate the most interest. It's difficult to maintain the viewer's interest with this type of rendering, though. The painting has a shallow feel to it; it doesn't let the viewer travel into the scene.

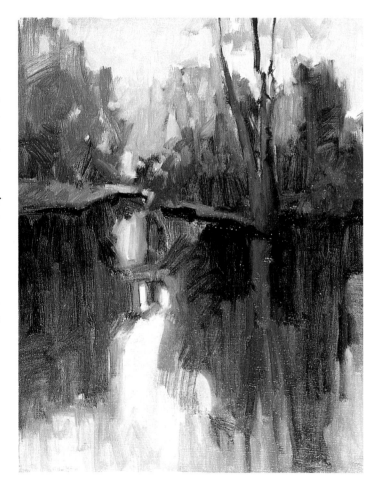

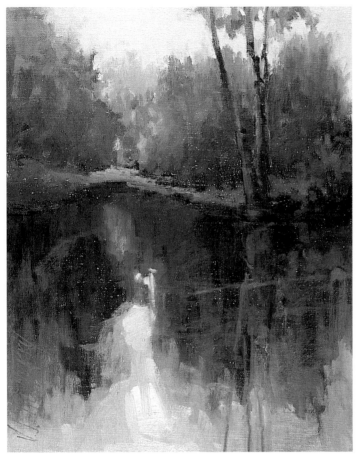

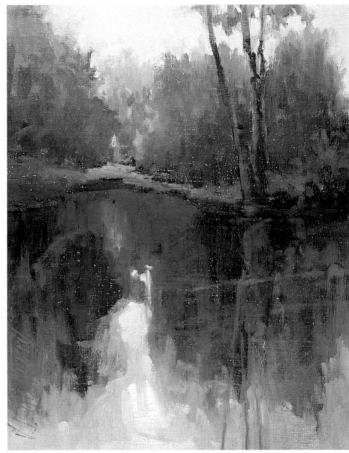

## 2 Critique the Work in Progress

I thought my interpretation of the scene was fairly good until I looked at it the next day. The purples in the water were simply too vivid for my taste.

I still liked the concept of using purples in the water, so I changed direction. I created a warmer mixture of Platinum Violet + Cadmium Yellow Light for the mother color. This warmed the purples in the water. I continued highlighting the abstract shapes in the water. I softened the tree shapes and also brought some of the warm color into the areas of the trees.

## 3 Cameras Don't Lie

I was pleased with the painting until I saw the slide I created of it I created. The Platinum Violet + Cadmium Yellow Light mixture photographs entirely different from the real image; it appears almost explosive in the photograph. I scumbled a thin mixture of Ultramarine Blue + Cadmium Orange + Titanium White over the reddish area only and photographed the painting again, with better results.

**Rustic Waters**
14" × 11" (36cm × 28cm)

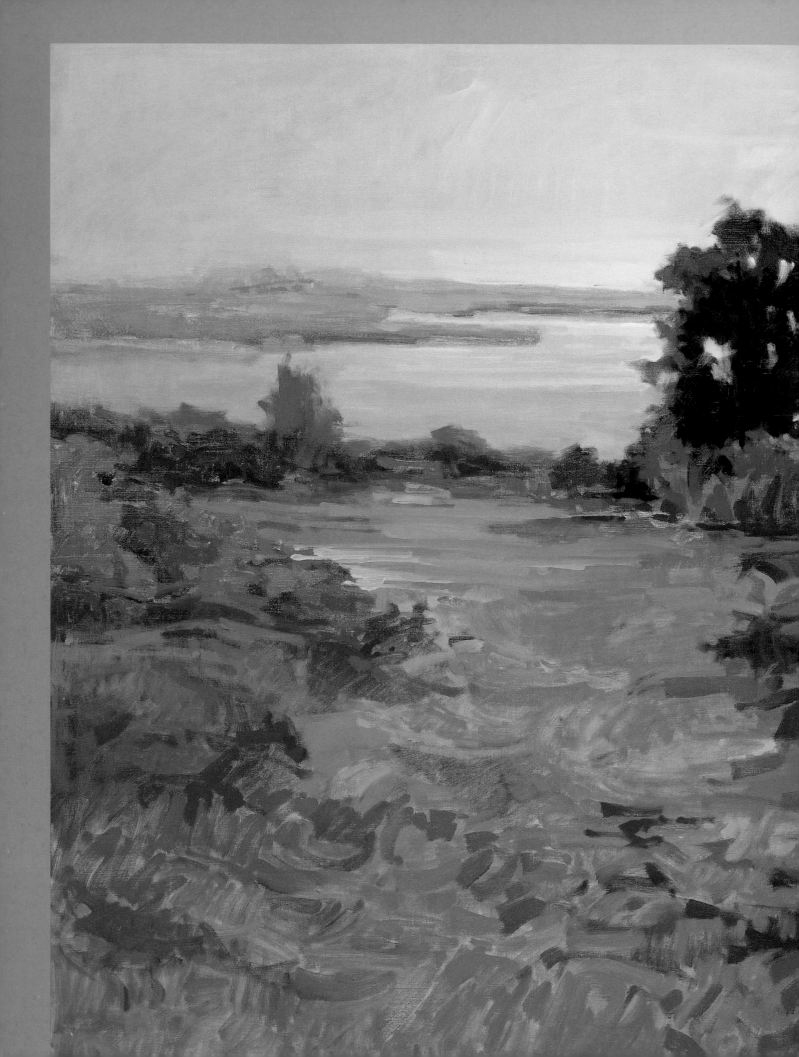

# Color Schemes

*The entire color universe is based on the the relationships between the three primary colors, plus black and white. There are five traditional color schemes that draw from these relationships: monochromatic, complementary, analogous, split complementary and triadic. These schemes illustrate various color combinations, relationships, harmony, compatibility and opposition. They're a great way to explore the color relationships. All colors are compatible, but in different ways.*

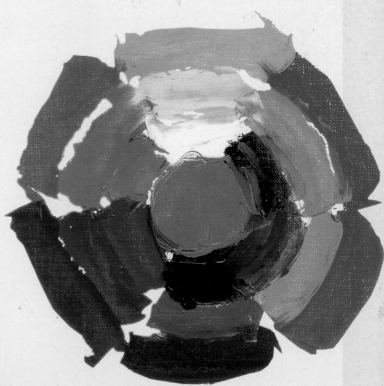

**Tapestry Treasure**
40" × 40" (102cm × 102cm)

# Color Schemes

Color schemes take all that you've learned about color relationships and really puts it into practice. For generations, artists have used color schemes for guidance in color selection or to add excitement and add a solid color foundation to their paintings.

There are five basic color schemes: monochromatic, complementary, split complementary, triadic and analogous. Each of these schemes has its place and, used correctly, they can have a powerful effect on the painting.

I rarely have an image of a finished painting in mind, so I generally don't pre-determine my choice of color for toning the canvas. I enjoy the surprise. I select colors according to my mood, unless the piece is a commission with certain expectations. I can relax and enjoy the birth and evolution of a painting that basically paints itself.

Occasionally, I will force an issue or technique to push myself to the next level of development. I still have a long road ahead of me. I must admit that I struggled the first fifteen years with each concept related to art. Applying acquired knowledge is a slow process.

## Color Scheme Studies

Creating studies that rely on color schemes is a wonderful exercise for a beginning painter. You will begin discerning your favorite combinations and stretching your color-mixing skills. I also recommend this exercise for the seasoned artist. Going back to the basics can help you refocus. Working with these color schemes can dramatically increase your skills and further your understanding of color.

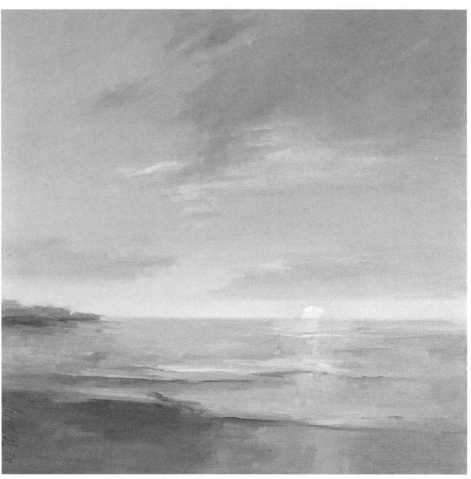

*The Principles of Color at Work*
When working with color, consider whether you want your colors to harmonize or contrast. Should they be equally balanced? Should one hue or temperature or value should dominate the painting? Ask yourself these questions as you make your color choices.

**Serene Sensation**
30" × 30" (76cm × 76cm)

# Monochromatic

A monochromatic color scheme takes one color as far as it can be stretched and still remain that color. Classic monochromatic paintings rely on a single pigment in a full range of values. You can certainly adjust a color based on temperature or saturation. I even use different pigments within my monochromatic paintings if I'm exploring the relationships between the different reds or greens, for example.

Monochromatic color schemes may be the most difficult to paint. It's a challenge to limit yourself to one color to express your vision. Though I may try a monochromatic study, I rarely use this scheme in a finished painting.

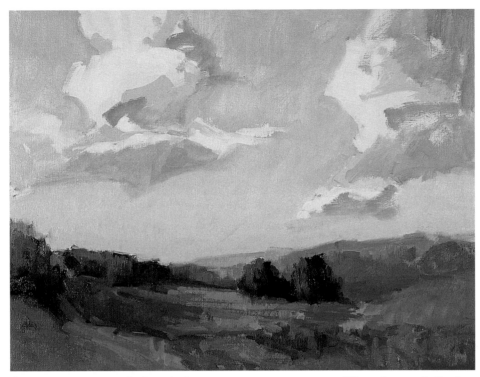

### Monochromatic Study
11" × 14" (28cm × 36cm)

*Monochromatic Color Scheme*
I chose red because it's a natural middle value. It can be easily lightened or darkened. Yellow would be a greater challenge because yellow has such a light natural value; it can only be darkened to middle value and still remain yellow. This is an excellent exercise in studying value and temperature. I mixed Cadmium Red Light, Alizarin Crimson and Venetian Red into the colors on my palette to maintain the red mother color (see page 54).

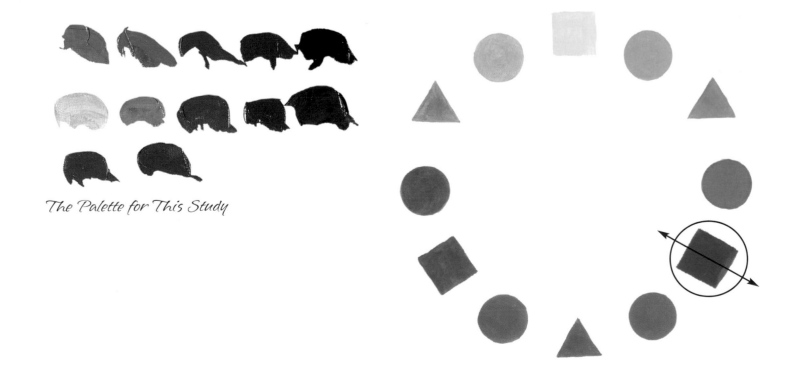

*The Palette for This Study*

# Complementary

Complementary colors consist of a primary color and its opposite color on the color wheel: yellow and purple, blue and orange, and red and green. Yellow's complement is purple because it contains the other two primaries, red and blue, but no yellow. Purple is yellow's opposite, just as green is red's opposite because it contains no red and orange is blue's opposite because it contains no blue.

As opposites, complements balance each other. If you place complements near each other, they "compliment" one another. Paired with each other in a painting, complements will sparkle.

Combining complementary colors is a wonderful way to make grays. You can mix such grays into your other colors. This helps stretched the range of values and temperatures of an otherwise limited palette, and it also creates natural harmony in the painting.

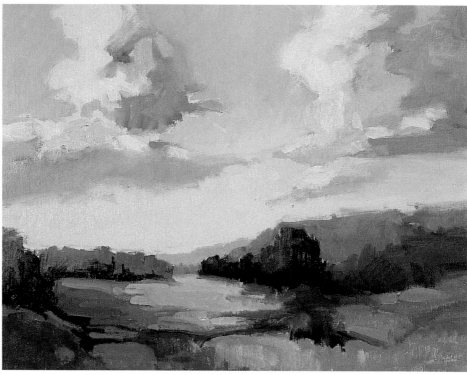

*Complementary Color Scheme*
I used Phthalo Green (cool) and Cadmium Red Light (warm) for this painting. Originally, I tried Phthalo Green and Alizarin Crimson, both cool colors, but the painting was too frigid for my taste. Changing the red to a warm red added the warmth and passion I wanted to achieve.

The fact that these are opposite colors provides contrast. Since the red and green are complements, blending the two together in varying degrees produces a range of harmonizing grays that soften the contrast.

**Complementary Study**
11" × 14" (28cm × 36cm)

*The Complementary Colors*
Setting a color next to or within its complement makes both colors stand out.

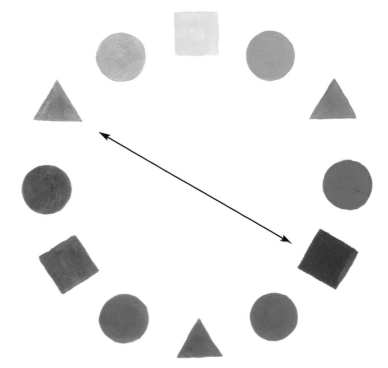

# Analogous

Analogous colors neighbor each other on the color wheel. When picking an analogous color scheme, you generally pick one color first and then select the neighboring colors. You can select just the two hues neighboring it or, like I did with the study below, include a larger range, but the range should never extend to include the primary color's complement.

Adjacent or neighboring colors combine well with each other and usually match each other in vibrancy. Because the colors tend to be similar, an analogous scheme can have automatic harmony, but might lack a point of interest. I suggest either using this scheme in a part of the painting that requires little attention. If you use an analogous scheme throughout the painting, I recommend placing a contrasting, complementary color at the point of interest; that will help pull the viewer's attention to this area.

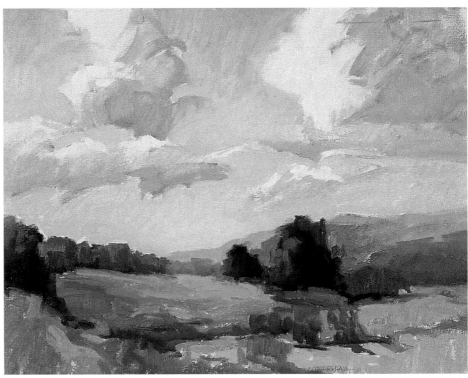

*Analogous Color Scheme*
For this study, I decided I'd to go with red and its entire range, from orange to violet and all the intermediate colors in between. Analogous colors tend to harmonize well, but the temperatures of the different pigments provide some contrast here. If I'd used all warm or all cool colors, I don't think the study would have held my interest.

**Analogous Study**
11" × 14" (28cm × 36cm)

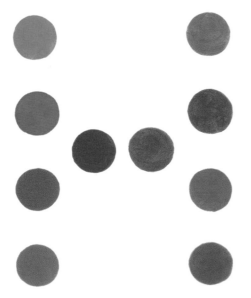

*Analogous Chart*
The analogous range of red is on the left and the analogous range of blue is on the right.

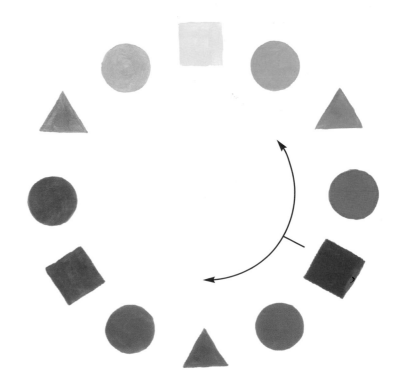

# Split Complementary

The split complementary scheme combines elements of the complementary scheme and the analogous scheme. It works with three colors. Select a color—let's say yellow—and then the two analogous colors of yellow's complement. Yellow's complement is violet, so you would need violet's analogous colors, blue-violet (cool) and red-violet (warm). This scheme gives you a broad temperature range.

*Split Complementary Color Scheme*
I used Phthalo Green (cool) and Sap Green (warm) as the split complements with Cadmium Red Light. In each of these studies, the emphasis is on value and temperature.

**Split Complementary Study**
11" × 14" (28cm × 36cm)

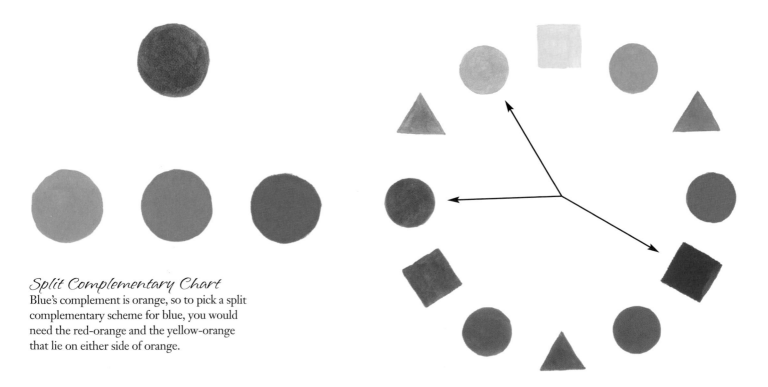

*Split Complementary Chart*
Blue's complement is orange, so to pick a split complementary scheme for blue, you would need the red-orange and the yellow-orange that lie on either side of orange.

# Triadic

A triadic color scheme is based on three colors (a triad) that are evenly spaced on the color wheel. I saved this color scheme for last simply because it incorporates the broadest range of color, temperature and value. Because of its expansive range, a triadic color scheme can easily get out of control if you're not careful. Sometimes its best to let one color or dominate. Handling this color scheme requires a broad understanding of color relationships and will open the door to other color theories.

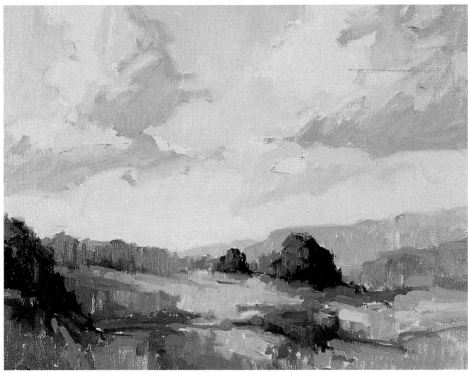

**Triadic Study**
11" × 14" (28cm × 36cm)

*Triadic Color Scheme*
I mixed a yellow-orange, red-violet and blue-green for this study. This is my favorite color scheme. I was able to mix colors that appeal to my personality.

*Finding a Triad*
To find your triad on the color wheel, make a triangle with equal-length sides and place it in the center of the color wheel. The colors at the points of the triangle are the ones to use in your color scheme. Rotate the triangle to find the other combinations you could use.

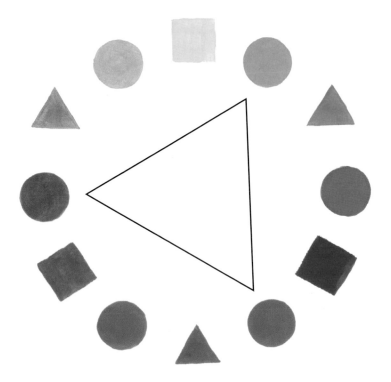

# Mother Colors

One wonderful way to produce a harmonized color scheme is to work with mother colors. A mother color is a single hue that is mixed with every other color on your palette. By mixing a single color into everything, you can introduce an enormous range of colors that will hold together like magnets. A painting based in a mother color isn't monochromatic it relies on the entire color wheel.

I first heard the term *mother color* in a Ted Goerschner workshop. He mixed some grays, which he referred to as "mother colors." He painted by mixing a gray mother color into his palette. This opened a whole world of color for me. I adapted his idea beyond grays; in my theory any color can be a mother color.

There is a natural bonding effect if the colors all lean toward one color on the color wheel. Most colors already lean

toward a primary color, but a mother color makes all the paints on your palette lean toward a single color. A sense of belonging to a family becomes apparent.

While adding a mother color to another pigment may affect its temperatures and values, you don't need to worry about that too much. The new mixed color's temperature and value should be measured according to its neighboring colors.

Working with mother colors will quickly broaden your color mixing abilities. Once again, preferences will prevail. Each artist will extend mixture combinations in a direction that appeals to him or her. Sometimes you need to push yourself toward other colors in order to grow.

## Seasonal Mother Colors

When plants begin blooming in the spring, I become emotionally charged. Although I have grown to appreciate the grays in winter, I'm drawn to the dynamic, saturated colors of spring and fall. For a spring palette, I might choose Cadmium Yellow Light (a cool light color) as my mother color. The yellow-greens of new growth in the spring are cooler compared to the yellow-greens in the fall. The same greens in the fall become muted in brilliance as nature prepares for the next stage. To depict the colors in fall, I might use Cadmium Orange as my mother color. Cadmium Orange is still high key enough to maintain some brilliance and also mute the colors. For a summer palette, though, the clear choice for a mother color is Cadmium Yellow to indicate the heat.

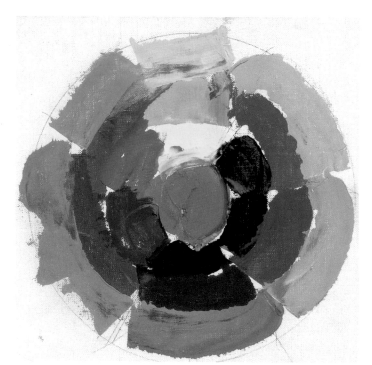
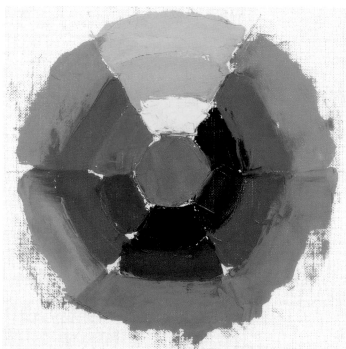

### Mother Colors
The color mixture at the center of each of these wheels is the mother color for the scheme (on the left, Quinacridone Violet + Cadmium Yellow Light; Cadmium Red Light + Phthalo Green). The inner circle has the pure, saturated pigments of the color wheel (as you'd find on my palette). The next circle has the pure pigments mixed with the mother color. The outer circle has these mixed colors lightened with Titanium White.

*Mother Color in Action*
By mixing a rich warm yellow into the other colors on my palette, I was able to maintain a glowing harmony.

**Golden Hills**
30" × 40" (76cm × 102cm)

## Determine Color Direction

Every color leans toward one of the primary colors. As you begin mixing colors, ask yourself if the mixture leans to the yellow, red or blue part of the color spectrum. Understanding this concept, developing your observations and applying this knowledge will save you hours of struggling to find the right color. A majority of the time, the solution to a problem to adjust either the temperature or the value of a color.

# Individual Colors

*Paintings talk to us. They tell a story through the languages of subject, design and color. I rely heavily on letting color speak for me. I willingly let subject and design take a backseat to color. Color speaks to me in volumes through vibrations that I can neither ignore nor overlook. Since color is my universal language, I devote more time-building a functional color family to express myself than to other aspects related to creativity.*

**Passionate Purple**
40" × 40" (102cm × 102cm)

# Exploring Individual Colors

Creating studies like these will get you started into the depths of each color (and you get to eat the subjects afterward!). Each of these studies requires extending a color in each temperature direction (warm and cool), using several values, and pulling the complement into the color scheme. I made neutral grays with the complements. I then used the grays to help extend the color value and temperature range. Neutrals make nice background colors. This allows the color of the subject to appear brighter and emphatically remain the point of interest.

For each study, you have two palette options. The first option for your palette is to mix one pigment or color (such as yellow) into the rest of your palette. (If I were going to use one yellow, I would choose Cadmium Yellow Light. I can manipulate Cadmium Yellow Light toward warmer and darker values with better results.) The second option for your palette is to use several different tubes of color and mix these pigments into the rest of your palette. If you decided to use yellow, you could use Cadmium Yellow Light, Cadmium Yellow Medium, Cadmium Yellow Deep, Indian Yellow, Zinc Yellow and even Yellow Ochre. Either method is a learning experience.

As you mix colors, fold them into the other paints on the palette. This form of mixing creates beautiful harmonies. It is an excellent habit to initiate now.

*The Palette*
This palette shows how I mix colors relying only on the pigments I generally use.

*Yellow*

*Orange*

*Red*

*Purple*

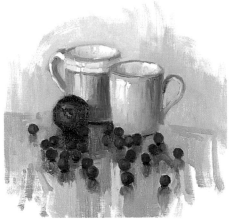

*Blue*

*Green*

# Properties of White

White is a precocious color; we need to have it on the palette, but it can be a nuisance. Students often use white to lighten the value of colors. They may have achieved the correct value, but they lose the luminosity in the process. Adding white makes a mixture chalky and opaque. If this is the artist's intention, then of course it's valid; but with newer painters, it's usually not what they intended at all.

White certainly has its attractions. Adding white to any color shifts the undertone of the combination to blue. This works well for lighter values in the background. (Lighter values in the middle ground should lean toward red, and lighter values in the foreground should lean toward yellow.)

Titanium White, Flake White, Zinc White and Permalba White are the most common whites. Some dry faster than others and some yellow less over a period of time. Since I find it to be the purest white, I use Titanium White—plus a small amount of Griffin Alkyd White to speed the drying process. I tend to work on several paintings at a time and often need for them to dry overnight.

## Two Methods for Working With White

Here are two methods for mixing white with another color.

The first method (left) is to glaze color over the white. I use this method often, especially while painting clouds. For this illustration, I laid down the Titanium White right out of the tube. After this dried, I painted a thin glaze of Alizarin Crimson over the Titanium White and some of the surrounding area. The glaze can be wiped if needed.

To the right of the glaze is a swatch of pure Alizarin Crimson and also Alizarin Crimson + Titanium White, which is the result of the second method. For the second method, I mixed Titanium White and Alizarin Crimson on my palette and then laid the color on the linen. Can you see the slightly bluish cast to the mixture? This frequently happens when you mix Titanium White with another pigment.

## Capturing Brilliance

I spent a long time trying to capture the brilliance of the sun on canvas. The first trick I discovered is to muddy the surrounding color. The muddy colors support the high-key light well.

The second trick I discovered is in painting the sun itself. The sun on the left is painted with a mixture of Cadmium Yellow Light and Titanium White. Its value is correct, but it doesn't appear as bright as the sun on the right. When painting the sun on the right, I first dabbed the canvas with Titanium White, then I gingerly applied Cadmium Yellow Light over the Titanium White. This sun is even brighter in value.

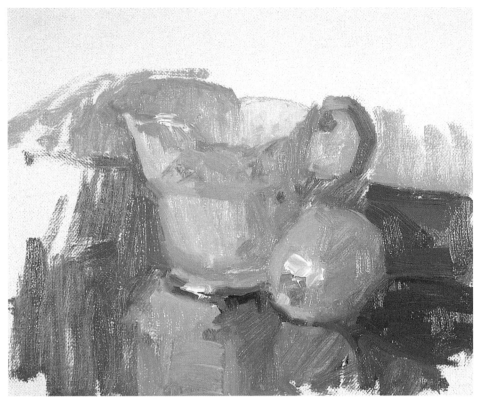

## The "Glob"—Just Go For It

Years ago, while I stood by indecisively, one of my teachers grabbed my brush, dabbed it into white and yellow, and hit the painting with one quick stroke, leaving a big glob of paint. I heard myself gasp. I'm sure that my heart was in my throat, but "globbing" it worked great.

I "glob" on occasion, depending on the degree of my current assertiveness. I can usually get to this point after I have tried several attempts to create highlight. Then reality kicks in and I remember that unwanted paint can always be scraped off. *Voilà!*

This little vignette demonstrates the effectiveness of a "glob" white. It works well as a highlight even on the light yellows and golds of subjects.

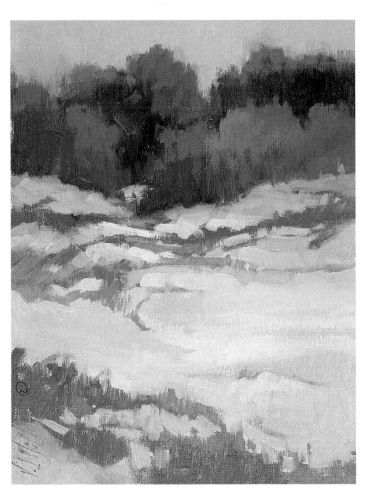

## Right Brain Sees Color

Our left brain sees snow as white, but our right brain sees additional colors. There are six whites in *Calligraphy in the Snow*. The cool whites are in the distance and in the dips. The warm whites are forward and on the horizontal surfaces.

**Calligraphy in the Snow**
12" × 9" (30cm × 23cm)

# Properties of Black

All light fades away with blacks. Transparent blacks reflect some light while dense or opaque blacks absorb the light.

## The Black Palette

For two reasons, I prefer to make my own black rather than purchasing premixed blacks in tubes. First, I don't need to buy it if I can make it. Second, I can make a large variety of blacks in any color direction that I need and either make them transparent or opaque.

Below, I've mixed blacks from the paints already on my palette. You'll notice that most of the blacks have a green and a blue at the base; since greens and blues tend to have naturally darker values, this is a good way to get your mixture as dark as possible. I've lightened each black two ways. I've added white to create the tints, but I've also come up the color wheel to lighten the blacks (usually with Cadmium Orange). The differences are dramatic.

Little vignettes are enticing. They're fast, fun and fantastic, especially as warm-up pieces in preparation for tackling a large canvas. Because I don't usually work with black, I decided to try some of these 15-20 minute vignettes to explore it. Experimenting with the different blacks was helpful. I was inspired to use blacks that I brought up the color wheel in two later paintings, *Terracing Clouds* (see page 128) and *Drifting Clouds* (see page 129).

*Phthalo Blue +
Alizarin Crimson +
Phthalo Green*
This black leans toward a cool blue, but could have leaned toward red or green. The paints in the mix are transparent, so they yielded a transparent black.

*Cadmium Red Light +
Ultramarine Blue +
Phthalo Green*
This combination made the most neutral black. Because Cadmium Red Light is quite close to Cadmium Orange, I decided to bring this black up the color wheel using Cadmium Yellow Light.

*Ultramarine Blue +
Alizarin Crimson +
Phthalo Green*
This black has a definite warmth to it. This is because Ultramarine Blue has underlying red notes in it. The Cadmium Orange works well with this warmth, and so is a good choice for lightening the black.

*Platinum Violet +
Ultramarine Blue +
Phthalo Green*
All three of these transparent paints have strong intensity and depth. This combination will remain decidedly cool no matter which direction the mixture leans.

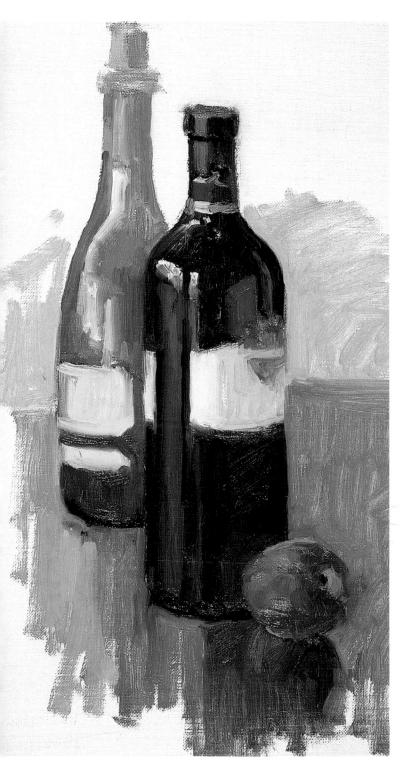

## Warm Up

I focused on the dark red wine bottle and decided to make my black with Phthalo Green + Platinum Violet + Alizarin Crimson. I wanted to keep the black in the red family and still be able to lean it toward green, red's complement.

There's still room at the top and bottom of the value scale to enhance the values and define form. I find it easier to see the correct range of value working with black rather than with color. The "almost" absence of color pushes value to the forefront of my thoughts.

## Delicious Fun

I wanted a black that would subtly emphasize the peach, so I used Ultramarine Blue + Phthalo Green + Cadmium Red Light to make a black and leaned it slightly toward red. In truth, any black would have worked. Different homemade blacks would create different color relationships between the peach and background.

For this study, I placed a peach on flat black paper with natural indirect sunlight from the window. Even though the black paper absorbs light, there were some interesting shadows reflecting the color of the peach.

# The Nature of Yellow

For *Yielding Yellow*, I wanted a yellow as the mother color, so I mixed my colors by adding Cadmium Yellow Light to every paint on my palette. I first blocked in my darks, then I progressed through the various values working toward the light areas. Most of the time, I continued mixing into the darks that I used for the block in. If I had the correct value, but wrong the temperature, I simply cooled or warmed the temperature by dipping into my original palette. Once I had the surface covered with paint, I checked my design and values.

### Pop Up the Lights

I used the purity of Cadmium Yellow Light and Titanium White for the highlights on the clouds. Cadmium Yellow Light has a cool temperature. When surrounded by warm colors, this coolness vibrates.

Subconsciously, we gravitate toward the light, so I exaggerated the light's vibrations by darkening the surrounding values a notch. These darker values help make the light pop.

**Yielding Yellow**
12" × 9" (30cm × 23cm)

## The Art of Manipulation

In *Hallmark Hills*, my point of interest is primarily the sun. I muted the warm yellows in the sky so that the cooler, saturated yellow of the sun would appear that much brighter. It helps that the sun, in addition to being the lightest light, is round. Round and square shapes are stationary, and our eyes will linger longer on stationary shapes.

The purple clouds complement the yellow, so they provide contrast of hue, but they're also cooler than the warm yellow to provide contrast of temperature, too.

This piece has a secondary point of interest: the glow on the distant hill underneath the sun. The design of the land leads our eye to the distant hill. I intentionally used grays for the hill to contrast with the purer, more saturated yellow of the sky. There's a thin line of almost completely pure yellow along this ridge below the sun. The eye is drawn to this point by the contrast in saturation but also by the change in temperature. The warm sky contrasts with the cool ridge, but there's change in temperature along the hill as well. The cooler purple-gray on the right gradually changes to a warmer, pinker gray on the left.

I used design, shape, value, hue and temperature changes to manipulate the viewer's eyes.

**Hallmark Hills**
18" × 14" (46cm × 36cm)

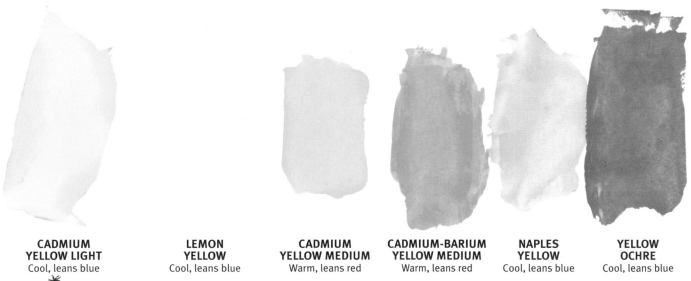

| CADMIUM YELLOW LIGHT | LEMON YELLOW | CADMIUM YELLOW MEDIUM | CADMIUM-BARIUM YELLOW MEDIUM | NAPLES YELLOW | YELLOW OCHRE |
|---|---|---|---|---|---|
| Cool, leans blue | Cool, leans blue | Warm, leans red | Warm, leans red | Cool, leans blue | Cool, leans blue |

*Yellow Pigments*
Of all the paints above I've sampled, I prefer to work with Cadmium Yellow Light.

# The Nature of Orange

Orange is one of the least popular colors on the color wheel. For this reason, it's rarely used in advertising or textiles. Despite this, I've found that I prefer mixing my darks with oranges instead of reds or yellows to lighten their value. Red is rarely light enough and tends to dull a dark, but yellow is frequently too much of a leap. Orange is often light enough and provides a warmth that I instinctively gravitate toward. Cadmium Orange and Phthalo Green combine into a wonderful, luminous dark value. Combining Cadmium Orange with various purples will create fabulous warm mauves.

## The Orange Palette

Mix Cadmium Orange into every color on the palette. I mixed three parts of Cadmium Orange with one part of each color on my palette, except Titanium White. you get to choose the ratio that appeals to you. Cadmium Orange + Ultramarine Blue will be the muddiest color on this palette, because orange and blue are complements. I use this combination to get a dull violet.

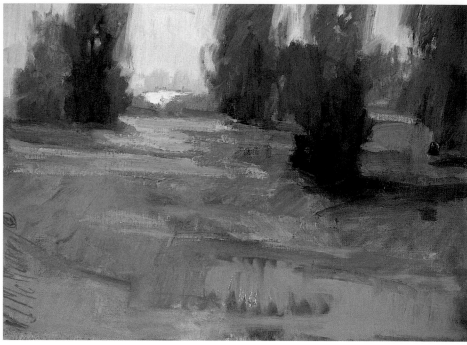

*Scumbling to Correct Color Harmony*

I began this painting as a midday painting (with very bright, saturated color), but apparently I wasn't in a sunny mood. The painting just lacked appeal. I finally decided I had nothing to lose; I shed my plan and went wild.

I ended up scumbling the painting with a thinned Cadmium Orange while the painting was still wet. By scumbling wet into wet, the Cadmium Orange integrated with the fresh paint and became the painting's mother color. I originally chose Cadmium Orange for this because of its warm temperature and mid-light value and after I stepped back, I decided it worked well. From that point on, I focused on the one color family to maintain harmony. The painting suggests a certain moodiness, but I'm pleased with the result.

**Ode to Orange**
9" × 12" (23cm × 30cm)

*Orange Pigments*
Of all the paints above that I've sampled, I've found that Cadmium Orange works best for me.

**CADMIUM ORANGE**
Leans Neutral

**TRANSPARENT ORANGE**
Warm, leans yellow

**CADMIUM ORANGE DEEP**
Cool, leans red

**MARS ORANGE**
Cool, leans blue

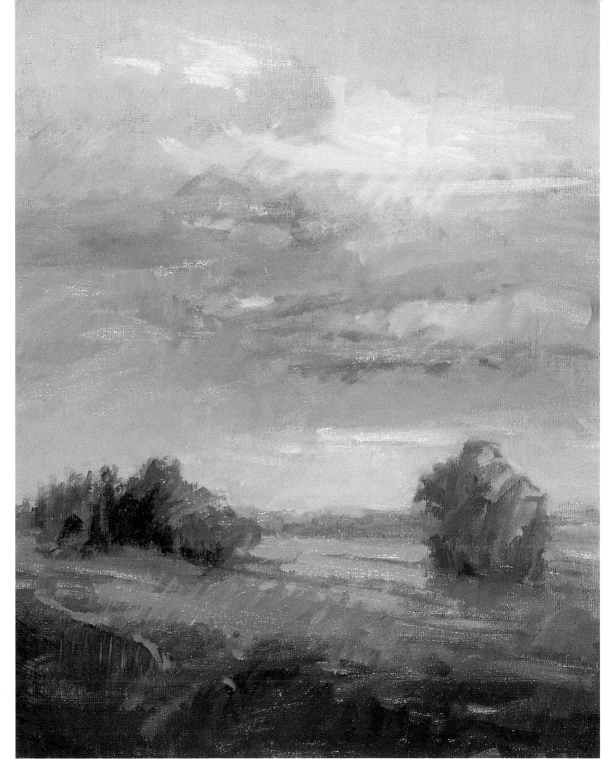

**Simmering Sensations**
14" × 11" (36cm × 28cm)

## Orange With Other Colors

To obtain that range of colors in the clouds, I scumbled in new colors with each session. I was able to maintain the color harmony by focusing on orange as the mother color. This process added a great deal of depth and interest to the clouds. By scumbling, I also created interesting abstract color patterns.

Using reds in the foreground was tricky. I went with warmer, desaturated reds to keep them in the foreground. If the reds had been too cool, the area would have contrasted too drastically with the warm painting and captured all of the viewer's attention. The eyes would have gone straight to that spot and then dropped right of the edge of the painting. Because this area is warm, our attention turns to the temperature contrast provided by the cool, light-valued sky. The oranges and blues complement each other so the sky has contrast of hue as well. Our attention might start in the landscape, but it moves up and lingers in the sky.

# The Nature of Red

The color red vibrates with emotion and energy. Intense as it is, it absolutely rules the color wheel. Our eyes are drawn to the red areas in a painting. They're so charged with energy that we have trouble looking away. Any color surrounding red gets ignored. You can try to subdue red by desaturating it, or you can work with red and surround it with desaturated colors. Whichever method you choose, don't underestimate red's draw.

Studies have been done in which people were asked to stay in a red room. The study revealed that the people were restless and could not stop moving. This may be why I avoid red as a dominant color in a painting; I'm already restless and have trouble sitting still.

Reds work well at or near the point of interest. Avoid bright reds near the edges, though. If our eyes are drawn to the edge of a painting, we may abandon it. Made restless by the reds, we let our eyes wander away from the painting entirely.

## The Red Palette

There are two reds that I generally keep on my palette: Cadmium Red Light and Alizarin Crimson. Cadmium Red Light leans toward yellow and is naturally warm, but it can be easily cooled with a cooler color. Alizarin Crimson leans

toward blue. It's far more difficult to warm Alizarin Crimson without sacrificing its brilliance. Combining of these two reds makes a neutral red.

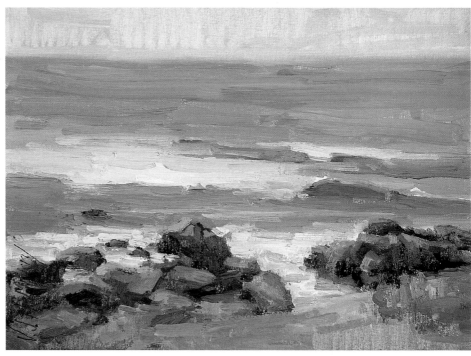

*Add Energy With Cool Reds*
I love the early morning and evening colors reflected in the ocean. Alizarin Crimson and Cadmium Red Light are the two mother colors in this painting. I preferred the colors mixed with Alizarin Crimson, but I used the Cadmium Red Light mixtures for the lights and darks of the rocks. The Alizarin Crimson group was useful in keeping the water a cool temperature.

**Rocky Reds**
9" × 12" (23cm × 30cm)

| CADMIUM RED LIGHT | ALIZARIN CRIMSON | RUBY MADDER | BRIGHT RED | IRON RED LIGHT | CADMIUM SCARLET | CADMIUM RED MEDIUM |
|---|---|---|---|---|---|---|
| Warm, leans yellow | Cool, leans blue | Cool, leans blue | Warm, leans yellow | Cool, leans blue | Warm, leans yellow | Cool, leans blue |

*Red Pigments*
Of all the paints I've sampled above, the two that work best for me are Alizarin Crimson and Cadmium Red Light.

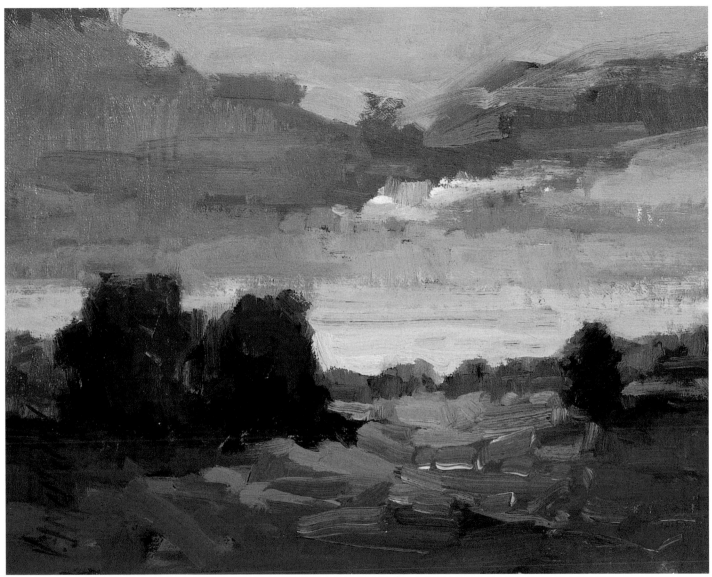

## An Explosion Waiting to Happen

In the past, I used reds sparingly, but the time came for me to learn red. *Embracing Passion* was my first attempt at tackling reds. I stretched red on both sides of the color wheel (hence the orange and purple) and introduced numerous grays. As you can see, it's an explosive painting. I'm still experimenting with dominantly red paintings. I'm taming red.

**Embracing Passion**
8" × 10" (20cm × 25cm)

# The Nature of Purple

Purple is an illusive color. By itself, it is hard to determine if it has a cool or warm temperature. It's easiest to read the temperature of a purple by placing it beside another color. Because temperature is an essential emotional trigger, purple sends a mixed message to our brains. Because of this, purple is rarely used in advertising. On the other hand, this ambivalence makes purples work well as a transitional color, especially when muted. They can also make a nice accent to neutral darks.

## Purple Palette

For *Predominantly Purple*, I combined Platinum Violet with every color on the palette. The pigmentation of Platinum Violet is very intense. I recommend the ratio of mixing about one part Platinum Violet to nineteen parts of the other paint. Platinum Violet + Cadmium Yellow Light makes your gray for this palette. Using it with the various colors will mute their intensity. Because *Predominantly Purple* has a shallow depth field, I didn't need the gray for distant hues, but I did use it for softening the abrupt changes in value.

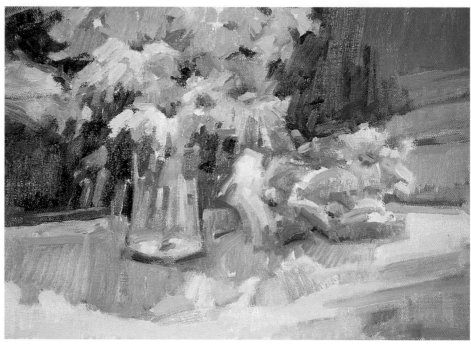

*Provocative Purple*
I used the cool Platinum Violet as the mother color for *Predominantly Purple* to emulate the cool spring season temperatures. The purple created just enough tension to exude excitement.

I put every color of the rainbow in this painting (the rainbow seems to be my current phase). The yellow flowers complement the purple mother color. The lavender flowers blend more with the surrounding colors.

**Predominately Purple**
9" × 12" (23cm × 30cm)
Collection of Betty Hood

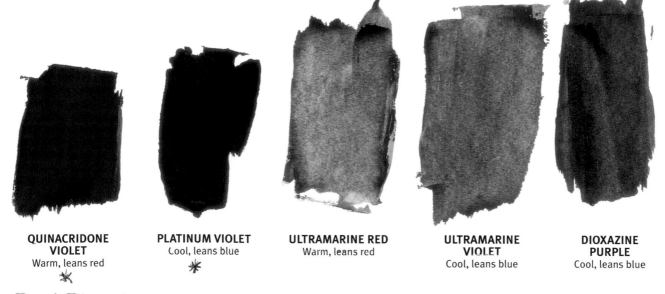

**QUINACRIDONE VIOLET**
Warm, leans red

**PLATINUM VIOLET**
Cool, leans blue
✳

**ULTRAMARINE RED**
Warm, leans red

**ULTRAMARINE VIOLET**
Cool, leans blue

**DIOXAZINE PURPLE**
Cool, leans blue

*Purple Pigments*
Quinacridone Violet and Platinum Violet are the purple pigments I keep on my palette.

## Vibrating Tension

The purples in this painting create a vibrating atmosphere. The uncertainty of purple creates a tense mood, as if a storm is approaching or about to break. The tension is increased by the orange notes sprinkled throughout. While not purple's complement, the orange is close enough to yellow to add contrast to the painting. The high-key, saturated orange crashes against the low-key, saturated purple in the sky.

*Passionate Purple* was just one of those paintings I had to get out of my system. Every nerve and sense in my body was awakened with passion. I will always remember my acute awareness of that sense when I look at this painting.

**Passionate Purple**
40" × 40" (102cm × 102cm)

# The Nature of Blue

Blue is the most universally appealing color of the spectrum. The vibrations of blue are calming and peaceful, so this color tends to comfort the viewer. Blue generally doesn't reflect too much light or absorb too much (though this can vary depending on the blue).

Blue is automatically associated with blue skies and water. Skies represent infinity in depth, thus allowing us enormous latitudes of space and freedom. A body of blue water suggests refreshment and relief.

## The Blue Palette

Ultramarine Blue is the only blue pigment on my standard palette. It's a nice, dark value that's easy to control. Occasionally, I use Cobalt Blue or Cerulean Blue. Cobalt Blue is equally efficient for painting, but it has a lighter value than Ultramarine Blue. Combined with Cadmium Orange, it makes a great neutral gray. Cerulean Blue is less luminous than the other blues, but it lends itself well to making spring greens.

Occasionally, I put all three blues on my palette for specific reasons. The three work well together to create big, open summer skies. Cerulean Blue + Titanium White will imitate the vast distances of the horizon. Cobalt Blue + Titanium White adds distance and clarity to the mid-sky area. Topping it off with Ultramarine Blue + Titanium White at the height of the sky adds enough value and temperature change to create the illusion of an intensely beautiful day.

These three blues have different temperatures. Using all three is an easy way to accomplish value and temperature changes.

*Artistic License*
The water was a variety of greens in reality. I chose to change it to blues for the emotional effect. The blue made the water seem cleaner to me, which made it a more inviting relief from the heat—the perfect place to play. I maintained the blue color notes in the skin tones and inner tubes. My intention with *Summer Friends* was to relay an upbeat message, so I kept it fresh and light. The joy of being young, the companionship of friends and the relief of cooling off in the heat makes for a perfect summer day.

**Summer Friends**
9" × 9" (23cm × 23cm)

*Technically, the light foreground is a cool mixture, but it appears warm next to the adjoining blues. By making the bottom left corner of the painting warm and leaving the three remaining corners cool, I made it my lead into the painting.*

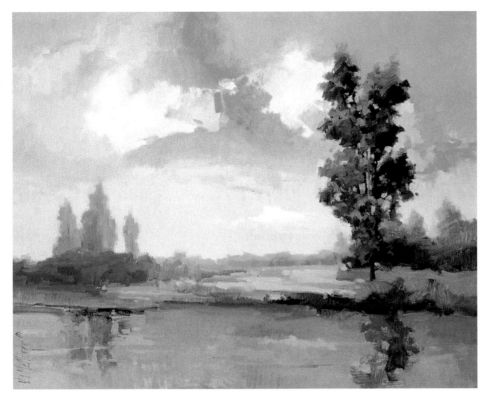

## The Three Blues

*Regal Trees* is a midday painting. I blued the harvest gold land to indicate the reflection of the sky. I used Cerulean Blue, Cobalt Blue and Ultramarine Blue for the sky. Because the sky dominates the painting, I had enough space to portray the range of values and push the depth. I stretched the blues in the water toward red to tie in the splash of a muted red along the bank. Otherwise, the splash would have been foreign to the painting. Ultramarine Blue + Cadmium Orange appears mauve beside pure blue. This also ties the blue sky and the orange hues in the clouds into the family of colors in the water. I kept the harmony by using my blues to make the greens.

**Regal Trees**
24" × 30" (61cm × 76cm)

**ULTRAMARINE BLUE**
Warm, leans red

**COBALT BLUE**
Neutral, stays blue

**PHTHALO BLUE**
Warm, leans yellow

**CERULEAN BLUE**
Warm leans yellow

## Blue Pigments

Ultramarine Blue is the blue I choose to keep on my standard palette.

# The Nature of Green

Some time ago, galleries were telling artists that green paintings didn't sell. This may have been related to the fact that decorators were also avoiding green. Some of the more muted greens starting coming back in the 1980s. Since then, greens are becoming increasingly more respectable in the eyes of the art world. Cutting an entire color from your palette to adhere to fashion is a risky thing to do; it's best to understand color and use it when it speaks to you.

## The Green Palette

Greens straight from tubes are intense and overbearing. Mixing additional colors into green softens the intensity. Especially with landscapes, take green up the color wheel (add lighter colors) before adding white. Adding white too soon will dull it.

In the warmer climate where I live, we have green foliage nine months out of the year. Spring, summer and autumn each have a unique green. Cerulean Blue + Cadmium Yellow Light is well suited for painting new foliage in the spring. Sap Green has a high concentration of red and works well for fall foliage. Phthalo Green can be used for spring, summer, fall and winter. However, Phthalo Green requires some studying to control the intensity of the pigment. Black + Cadmium Yellow Light is a pleasing green and well suited for most landscapes.

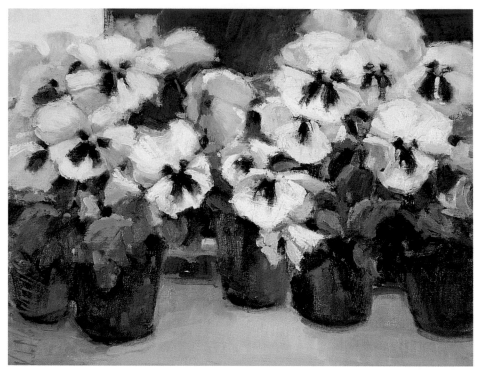

### Changing Directions

*Potted Pansies* is a good example of changing directions midstream. Originally, I based this painting on Phthalo Green. The mixtures worked for the pots but not for the leaves, glass or pansies. Black + Cadmium Yellow Light is an excellent green for most foliage, so I used that instead. I continued to work on this painting with the new green and reworked some portions.

For the finishing task, I applied Phthalo Green + Titanium White as a transition color. The dark glass surrounding the white petals appeared too severe. By adding this particular transition color, I added the sparkle that the painting desperately needed. Because Phthalo Green is a cool green, it worked. It stayed in the background and sparkled.

**Potted Pansies**
11" × 14" (28cm × 36cm)

**PHTHALO GREEN**
Cool, leans blue

**PHTHALO YELLOW GREEN**
Warm, leans yellow

**PERMANENT GREEN**
Cool, leans blue

**SAP GREEN**
Warm, leans red

### Green Pigments

I've found that the cool, blue-leaning Phthalo Green meets most of my needs for a green.

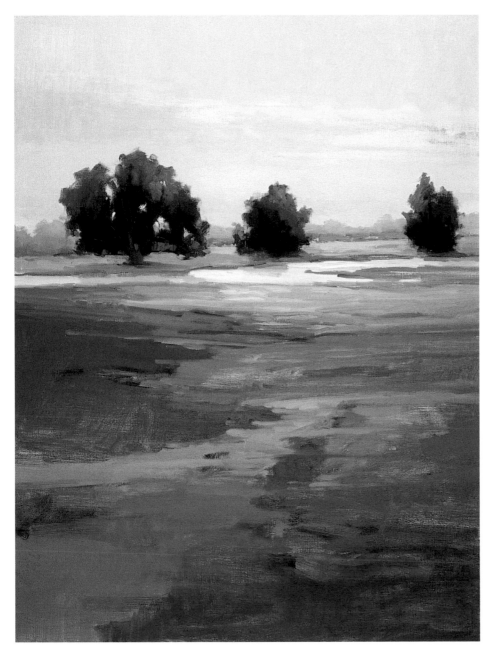

*Keeping It Cool*
I used Phthalo Green and a lot of purer, unmixed greens for this painting. I used cool greens in the foreground and grayed, warm, lighter greens in the distance. This gave the scene a backlit appearance. I held the harmony together by continuing to use green into the sky area.

**Gentle Greens**
24" × 18" (61cm × 46cm)

*Use abstract shapes in large foregrounds to take you to the middle ground, then break it up with different values and temperatures to modify large spaces. In this painting, I also placed my horizon line at the point that creates a square within the vertical rectangle. These are wonderful tools for breaking up spaces.*

# Complementary Grays

Grays can add form and depth to your work. Early in my career, I painted mainly high key and shied away from the grays. Grays, for me, meant the glass was half empty. In reality, my observation skills were not developed. I didn't see the color in grays until I began comparing them to the primaries; only then did the "Aha!" factor kick in.

As I began painting with grays, I realized how effective they are for supporting the light. I understand now that using

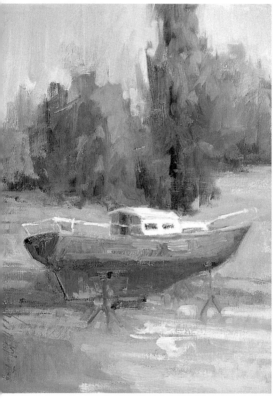

### Making Choices

For this painting I used an orange/blue gray to echo the dominant colors of the boat, the center of interest. I could easily have used the yellow/purple gray or the red/green gray. The yellow/purple warm gray would have added more of an overall yellow glow to the painting. The red/green warm gray may have tied the red part of the hull and the green foliage together. Choices do make a difference, even if it is subtle.

**Restoring Glory**
12" × 9" (30cm × 23cm)

*Originally, I had the tall tree on the left side of "Restoring Glory." After catching a glimpse of it, my daughter pointed out that the back of the boat and the large tree were both on the same vertical plane; this weighted the painting too heavily to one side. I reluctantly relocated the large tree. As it turns out, she was right. The painting looks more balanced this way. This design creates a nice pull into the painting at the boat's hull, then lifts the eye up the large tree and back down to the smaller tree.*

### Two Grays Combined

*Ah! Ballet* was one of my first attempts to explore the red/green grays. I created five values of Cadmium Red Light + Phthalo Green and five values of Alizarin Crimson + Phthalo Green and used both grays throughout the painting. The toe shoes are the center of interest, so this is where I intensified the value contrast to support the lights. I accomplished this by relying on the purer notes with Cadmium Orange and Cadmium Yellow Light. The visual effect of the image is like looking through tulle, the netting fabric used in ballet costumes. The use of grays pushes the image and adds more depth.

**Ah! Ballet**
24" × 30" (61cm × 76cm)
Collection of Jennene and K. Ray Mashburn

gray is vital for maintaining balance. Once I crossed this line of development, I couldn't go back. Grays opened a whole new world for me to explore.

The nice thing about painting with grays is the depth of field or distance created by using them. With grays is easier to achieve a three-dimensional effect on a two-dimensional surface.

Mixing each complementary pair of colors produces an immense selection of grays. Yellow + Purple, Blue + Orange, and Red + Green are the complement combinations. Combining these colors in various proportions will produce unique grays, some warm and others cool.

At times, the subject will determine which gray family is the best solution to achieve the desired affect. I prefer to let artistic license prevail in determining my choice of gray. Of course, the best way to discover your choices is to do several paintings of identical subjects using different grays. We all have our favorites at different stages of our careers.

Experiment with different gray mixtures. Create your own color combinations to make gray. You will discover your favorite palettes of gray and which grays work for different situations. Experimenting is exciting. It is a measurement of each stage of creative development. Art patrons enjoy communicating their knowledge of an artist's career. Give them something to discuss.

Alizarin Crimson + Phthalo Green · Cadmium Red Light + Phthalo Green

### Red + Green

Making gray with Alizarin Crimson + Phthalo Green produces nice, cool sherbet grays. Alizarin Crimson and Phthalo Green are both transparent colors, so they'll maintain clarity while changing the temperature from cool to warm. They both lean toward blue, which also keeps the temperature cool. Cadmium Red Light + Phthalo Green makes a warm, rich, dense gray.

Cadmium Orange + Ultramarine Blue

### Blue + Orange

If the subject is mainly blues or oranges, this gray (Cadmium Orange + Ultramarine Blue) is a good idea. It lends itself well to paintings with an abundance of atmosphere, because blue is associated with atmosphere. Landscapes where you can see the distant hills receding into the horizon have lots of atmosphere. Each hill progressively gets bluer with distance. For window-lit still-life paintings, this combination does a good job suggesting the blue sky as the light source.

### Yellow + Purple

Mixing Cadmium Yellow Light and Platinum Violet results in a warm gray. This warm gray tends to soften the visual effect of the painting and add glow at the same time. I prefer this gray as the mother color if I'm using many yellows and purples in the subject. For a cooler gray, try a bluer purple such as Dioxazine Purple.

Cadmium Yellow Light + Platinum Violet · Cadmium Yellow Light+Dioxazine Purple

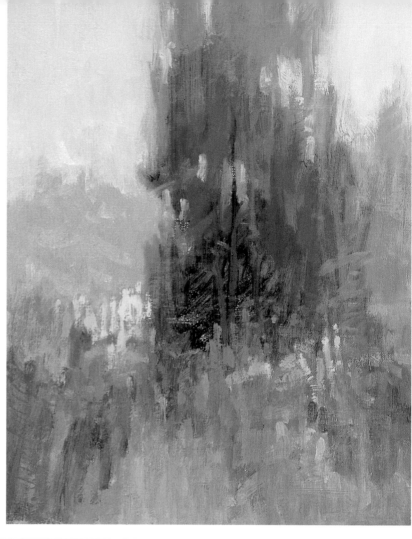

## Same Palettes, Different Uses

Cadmium Red Light + Phthalo Green + Titanium White is my gray for *Fall Pastures* and *Peaceful Garden*. The light source for both paintings is to the right and slightly back. The green foregrounds are treated differently. *Fall Pastures* has a cool green foreground to indicate shadow with the distant light remaining cool but warmer than the foreground. The foreground greens in *Peaceful Garden* are warm to indicate the close proximity.

**Peaceful Garden**
12" × 9" (30cm × 23cm)

*The hedge in "Fall Pastures" is broken at the point of interest. The break allows a visual passage into the background. The tree in "Peaceful Garden" is placed off center enough to break up the sky spaces into differently sized vertical rectangles. Both circumstances escaped repetition and added more interest.*

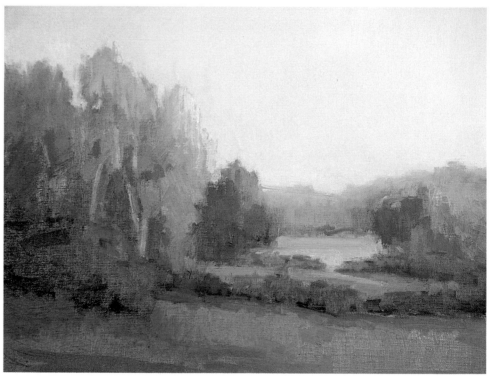

**Fall Pastures**
11" × 14" (28cm × 36cm)

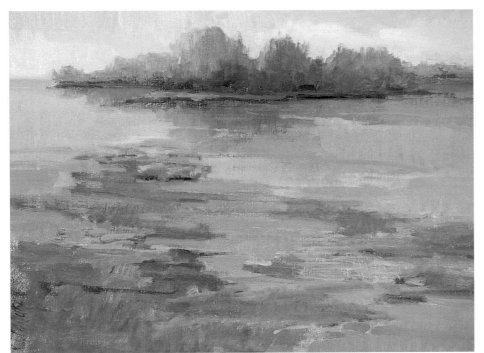

### Enough Is Enough

The warm foreground yellows come forward while the cool yellow in the tree recedes. More excitement could have been created by using less of the gray mixture while mixing the foreground areas. I decided to leave the painting soft and not try for more punch. I redesigned the washed-up seaweed and used it as a tool for a lead-in to the light. The bottom right corner resembles an arrow, which can take the eyes off the painting. The close values make the arrow unnoticeable.

**Synthesizing Yellows**
14" × 18" (36cm × 46cm)

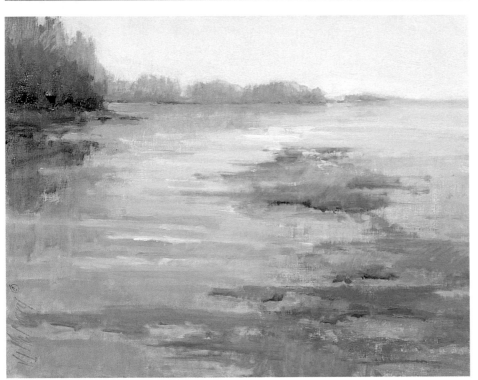

### Painting Companions

Companions for paintings are requested. The horizon lines are placed at the same level in *Synthesizing Yellows* and *Gateway to Serenity*. The point of interest in *Synthesizing Yellows* is top left while the point of interest in *Gateway to Serenity* is top right. Composition is handled individually and for the pair.

**Gateway to Serenity**
14" × 18" (36cm × 46cm)

# Earth Tones

Ready-made earth tone paints range in temperature and value among companies supplying oil paints. I rarely purchase these colors or put them on my palette. If they're on my palette, chances are I'll make a muddy mess of my painting. Secondly, I don't need them because I can make them. By making my own, I can maintain the luminosity.

There are many ways to mix earth tones. Here I show four different options. These all produce rich, clear earth tones of varying value and temperature. Use these options as a starting point to explore other combinations.

When it comes to painting with earth tones, I recommend that you reintroduce purer hues throughout a painting. Try a

stroke of Quinacridone Violet beside Burnt Sienna. The Burnt Sienna will make the Quinacridone Violet look especially great.

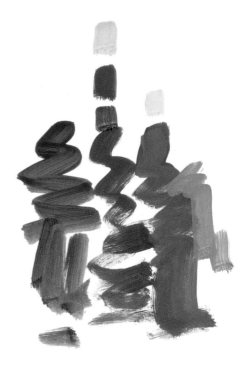

## Option One: Primary Colors

This chart illustrates the use of primary colors to make various earth tones. All of these are mixed from primary color pigments found on my palette (Cadmium Red Light, Cadmium Yellow Light and Ultramarine Blue). By leaning the colors toward blue or red or yellow, I can create quite a range of colors that I vastly prefer to the tube colors.

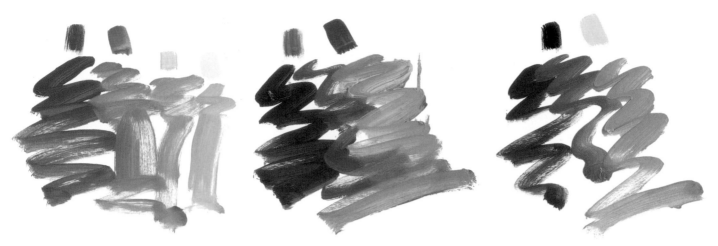

## Option Two: Complementary Colors

To make the earth tones this way, I mixed the complementary colors and then added yellow to lighten the value.

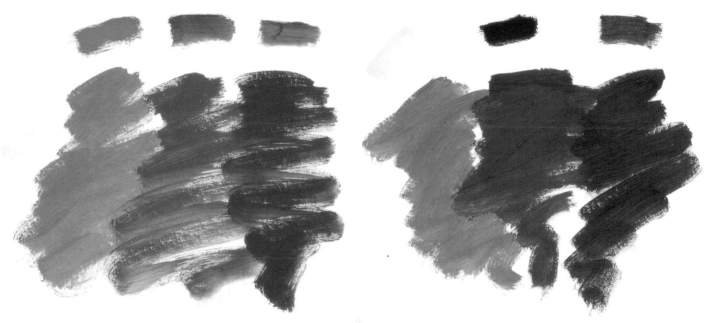

## Option Three: Secondary Colors

Combining the secondary colors also produces a variety of earth tones.

## Option Four: Cooler Primary Colors

This example replaces Cadmium Red Light with Alizarin Crimson.

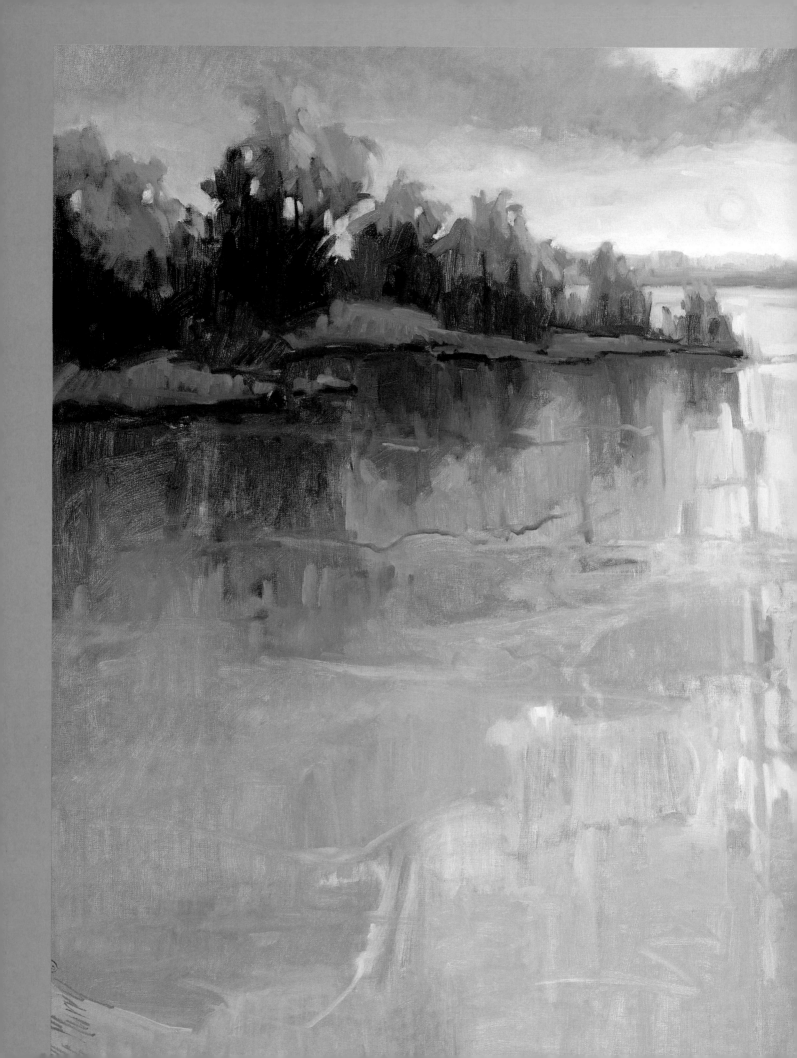

*Part* 5

# Color and Light

Correct lighting cannot and should not be overlooked. Done correctly, the lighting of subjects will enhance your work. If the treatment of the lighting is incorrect, it will absolutely detract from your work. Art judges will know in an instant if you handled the light correctly or not. General audiences, too, can sense something wrong, even if they can't pinpoint what.

Always take a few minutes before painting a subject to study the light. There are three key elements to introducing light into your painting: value planes, light direction and light temperature. Know ahead of time how you intend to interpret the light. If you focus primarily on capturing the light, the appearance of form transpires automatically as you paint.

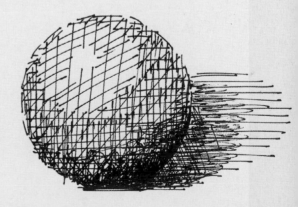

**Mellow Morning**
30" × 30" (76cm × 76cm)

# Value Planes

Any object has geometric planes which reflect or absorb light. How these planes react to the light determine its color. For objects, I simplify to three value planes: light, medium and dark. The medium value is the local color, the color of the object. The light value is where the object reflects or absorbs the light. The dark value is in shadow.

When I paint landscapes, I try to have four basic values: light, two medium values (light middle and dark middle) and dark. I establish the sky as the lightest; because this is the source of the light, that makes sense. Usually, I designate the land as the light mid-value because it reflects the most light from the sky. Any slanted surfaces work best as the dark mid-value because they don't directly face the sky. I reserve the darkest values for the vertical surfaces because these receive the least amount of light. Of course, this assumes the light is coming from overhead.

Light    Light Mid-Value    Dark Mid-Value    Dark Value

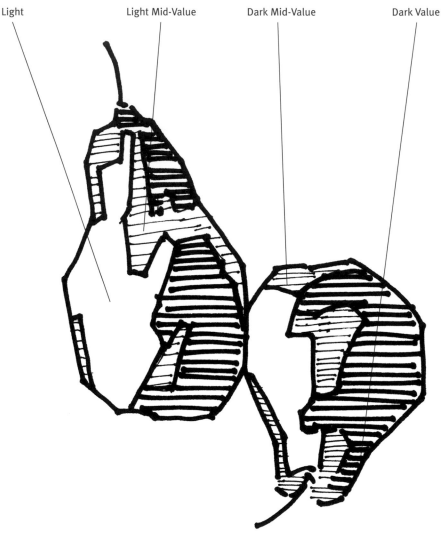

*Planes Have Geometric Shapes*
Pears are great subjects for studies because they have many planes. I saw all of the planes, but chose to keep the pear simple.

*Match Your Planes*

An interior designer once told me her theory that all horizontal planes should be in the same color family. For example, she chose a countertop to match the carpet. In some sense, landscape painters can use the same rule.

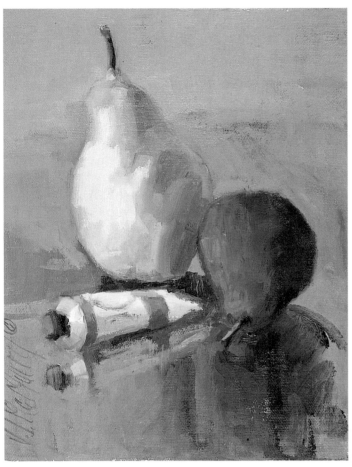

### Keep It Simple

In this study, the waxy green pear definitely indicated a blue reflecting light. I enhanced the blue light by placing yellow light directly beside it. The middle value or local color of the green pear leaned more toward blue than yellow. I just had to put some middle values leaning toward yellow next to the blues. The darkest value, the plane farthest from the light, is a blue-green. By alternating temperatures in each plane, I created color relationships that truly help celebrate the colors' nature.

The skin of the red pear is thinner and rougher. It reflected and absorbed light. I took artistic license and chose to celebrate the light by keeping the light plane in the red family. The true reflection leaned toward blue with less intensity than the green pear. I painted it as I saw it. I had a "blah" reaction, so I tried a tint of red-orange.

**Pear Study**
10" × 8" (25cm × 20cm)

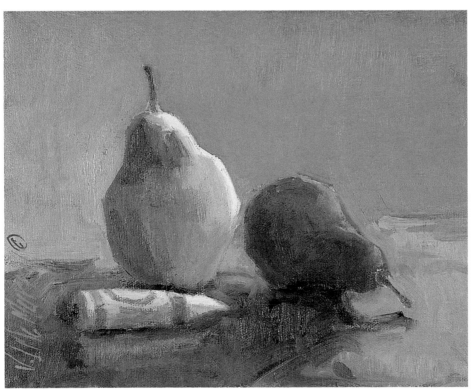

### Soft Drama

This study is backlit. The angles along the edges of the objects catch the light. Because of the temperature and value differences, the dark side of the green pear has a hard edge against the neutral background. Hard edges are most suited for the points of interest. I chose to leave the edge that way primarily because the lighting is dramatic; the painting needed strength.

In both studies, reflective light is indicated by "bouncing" red reflections of the red pear onto the green pear on the angle that would catch the reflective light. Reflective light is a fabulous way of bouncing color around a painting. Isolated color is too intense for our senses and will appear foreign. Just as people feel a need to bond with other people or groups, colors also need to bond with additional colors. The simplest way to build color relationships is through reflective light. Reflective light in reflections is normally darker than the light it is replicating.

The cast shadows became a design tool. They break up space nicely and relieve just enough tension so that our eyes rest from the intensity of the objects.

**Pear Study**
8" × 10" (20cm × 25cm)

# Light Source and Shadows

Think about light in three ways: source, reflection or absorption, and temperature.

## Light Source Direction

The direction of the light is one of the first things to establish. This applies to indoor still-life as well as plein air painting. Once you have your subject and easel set up, determine the direction of the light source as it appears as you look at the subject.

You can identify the direction of the light according to the hours on the face of a clock. There is side lighting, which can come from above (10:00 or 1:00), from the sides (9:00 or 3:00) or from below (7:00 or 5:00). Overhead lighting occurs when the light source is directly overhead, at high noon (12:00). Bottom lighting comes from below the subject (6:00). These lighting positions will all illuminate a portion of the subject and its edges.

If the light is coming from behind you and you are outdoors, a long shadow will be casting in front of you. The subject is receives the maximum exposure of light illuminating many planes. I do not recommend this lighting for landscape painting because there isn't enough contrast. It's difficult to establish a significant point of interest. A still life lit in this manner may still have enough values expressed by the local colors of the subjects.

Light that comes directly from behind the subject is known as backlighting. This is a very dramatic light source. I assume that is why this is my favorite lighting.

Ask yourself if the lighting arrangement that you see justifiably lights the subject. If not, this is a good time to move your easel (when outdoors) or move the artificial light (when indoors).

## Shadows

Cast shadows are very important in establishing your light source, and they also provide wonderful value contrast. Cast shadows may appear short (12:00), long (4:00, 5:00, 7:00, 8:00) and backlit, or not at all (diffused lighting). I am very careful to avoid paintings with little or no shadow. Cast shadows add the necessary middle-to-dark range of values to portray form. I prefer to paint subjects with long cast shadows. Long shadows add another level of depth and more contrast to the composition. I can optimize design.

With diffused lighting—such as on a cloudy day—the light source is indistinct and the shadows are minimal, sometimes nonexistent. I don't recommend this type of lighting as a general rule because you deny yourself the powerful impact of shadows and highlights, but it can sometimes result in an interesting painting.

*Overhead Lighting*
This drawing indicates an overhead (12:00) light source. The lightest light is on the top plane that faces the light. The darkest dark is the vertical trunk. The cast shadow is directly beneath the tree and also indicates the direction of the light.

*Side Lighting From Above*
This drawing indicates the light source to be at about 10:00. The lights on the tree will be on all right angles to the 10:00 light source.

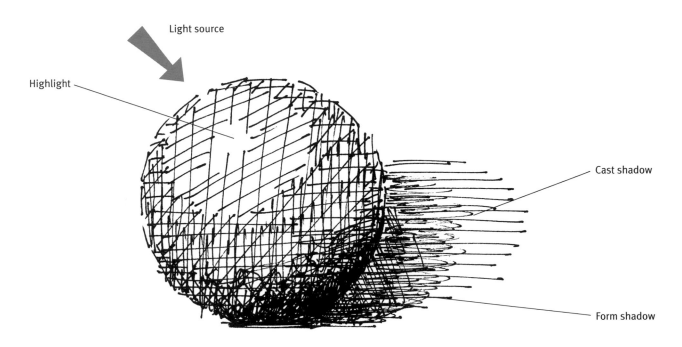

Light source

Highlight

Cast shadow

Form shadow

## Shadows and the Sphere

Circles are unique. Depending on the direction of the light source, concentric circles are formed from the light to the dark. The drawing indicates an 11:00 light source. The cast shadow becomes an oval. The shadow values are darkest nearest the object and gradually get lighter with distance from the object.

Where the light hits the object directly, we see the highlight. Where the light doesn't directly touch the sphere, we have the form shadow.

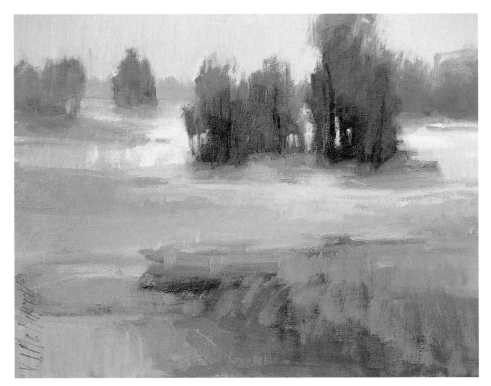

## Diffused Light Source

I did not have a light source in mind at the beginning of this painting. I painted in my dark verticals (trees), middle values (land) and then the sky. I placed the group of three trees at my point of interest. Initially, I planned to paint some high-key yellow flowers in front of the trees to fulfill the rule that your darkest darks and lightest lights should be placed at the center of interest. However, I liked the diffused light of the sky from my block-in. Stronger value contrast would have suggested a stronger light source.

**Distant Glow**
11" × 14" (28cm × 36cm)

# Reflected Light

I would like to say that all glass-like or waxy subjects reflect the same color as the light source, but this is not always true. There are other influences involved. Reflective light is light bouncing off of surfaces. Other surfaces absorb the light; for those, such as the light source direction and the subject's texture, the light is represented or indicated by a lighter value of the local color.

This is the point where my daughter would say, "Too much information," and she would lose interest and walk away. I agree that this seems like sensory overload. Becoming familiar with various lighting situations will enable your lighting sense to become second nature. I highly recommend plein air painting as a method of learning scenarios of light and subject relationships.

I like to use reflective light in areas that need more color. First, I need to determine if reflective light is possible. In *Classical Café*, the answer is yes. The light source is on the left. Therefore, light could be reflecting off a sign or window out of view on the right. I mention this for representational purposes. An Expressionist sacrifices accuracy to obtain expression.

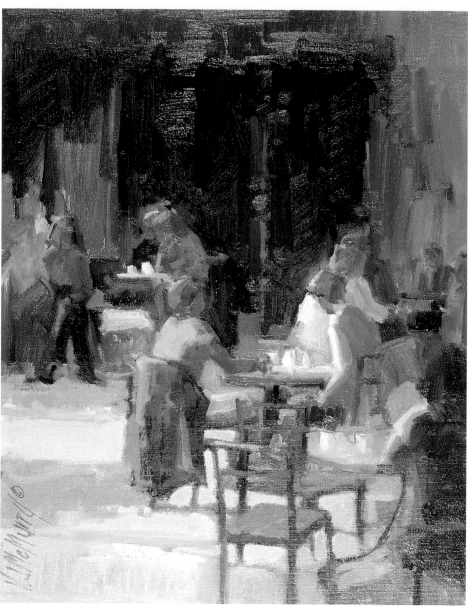

### Add Sparkle to Darker Areas

Handling colors in the light is relatively easy. The darker values surrounding the light really make the light catch your attention. This effect is enhanced by using both cool and warm color temperatures in the light.

I had difficulty capturing excitement in the lighter planes of the jacket over the chair, one of the dynamic points. Each time that I lightened the color, the mixture appeared chalky. Because Cadmium Red Light always draws attention, I tried it. It was just the sparkle that I needed. The color on the vertical plane beneath this spot also leans toward red, which supported my decision.

I needed to move the Phthalo Green vertical stroke in the dark area into the light area to avoid isolation and for eye movement. I tried a lighter version on the horizontal plane of the distant table. I changed the temperature by adding Cadmium Yellow Light and applied this to the horizontal plane of the middle table. By changing planes and temperatures, I eliminated repetition.

**Classical Café**
14" × 11" (36cm × 28cm)

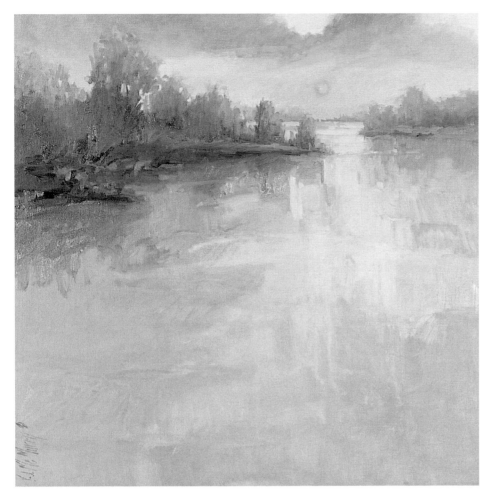

### Multiple Light Areas

Using reflected light allows you to paint multiple light areas. Here, the orange sun is the light source. The orange sunlight reflects off the clouds, but the most dramatic light areas are in the water where the sun's reflection is spliced and broken by the current.

**Mellow Morning**
30" × 30" (76cm × 76cm)

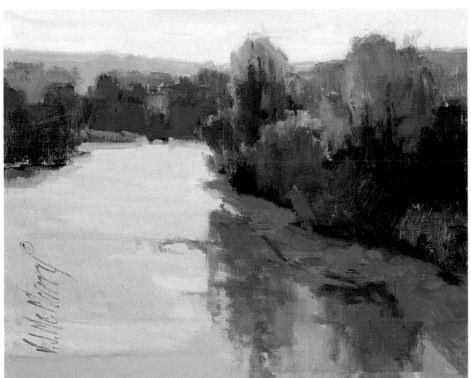

### Temperature and Light

I love huge skies in my paintings, but here I used the water to reflect the intense light of the sky. For some magical reason, I chose a warm hue for the sky. The warm sky, its reflection in the water and the warm foreground treetops allow our vision to maneuver easily within the painting. A choice of a cool sky and reflections would have resulted in a chalky painting and isolated the foreground tree tops—too much visual tension.

**Wintry River**
8" × 10" (20cm × 25cm)

# Light Temperature

Often, subjects lit by the sun are painted with yellow because we perceive the sun's light as yellow. This sends our brains a message that we interpret as heat. The time of day and the subject will determine the temperature of the light. Late afternoons can be expressed by using warm light. Early mornings often have cool light. Warm and cool temperatures are present in outdoor light.

Artificial light was mainly yellow or warm until recently. Now, we can purchase lightbulbs that illuminate in many colors. I recommend GE Reveal lightbulbs. They are inexpensive, and they light subjects true.

## Color in Shadows

One way to paint shadows is to use exclusively warm or cool colors. The shadow temperature is often determined by the subject or by reversing the temperature of the light. The light may be handled similarly. I prefer to see both warm and cool temperatures used in the shadows as well as in the light.

I like for my vision to travel throughout a painting. If any area becomes monotonous in temperature, my eyes will search other areas, looking for emotional excitement. The excitement and sparkle occurs when temperatures are alternated. We expect to see the sparkle in the light. Finding sparkles in shadows is a pleasant surprise. This phenomenon reaches our deepest emotional desires. The experience is always pleasurable.

*Warm and Cool Shadows*
The shadows in the rocks have both warm and cool darks. The lights on the rocks also display both temperatures. Realistic art depicts the light source temperature consistently on the planes reflecting the brightest light. Artistic expression allows for the freedom to incorporate what we want to see. I like to exercise temperature changes throughout a painting regardless of the true conditions. Our eyes will naturally gravitate to the light. Alternating the temperature (but keeping the value correct) in the dark areas balances color and temperature distribution.

**Rock Patterns**
11" × 14" (28cm × 36cm)

## Warm Evening Light

I was actually glad that I caught the red light at this intersection. Waiting for the light to change, I noticed these redheads on the corner. The evening light produced compelling highlights in their hair. The painter in me decided I had to paint this scene (though the mathematician in me wondered about the odds of finding three redheads at the same stoplight).

I painted all of the values fairly muted. For the direct highlight on the pole, I first laid down Titanium White and then added a stroke of Cadmium Orange + Titanium White. For the reflected light on the other side of the pole, I used Platinum Violet + Titanium White. Once the painting was dry, I scumbled it with Cadmium Orange. This made the light very warm.

**The Stop Light**
12" × 9" (30cm × 23cm)
Collection of Don and Linda Harris

*This is a great study of light. Not only does the evening light have wonderful rich warmth, but it also causes beautiful, long cast shadows. In addition to that, the pole shows some reflected light (the Platinum Violet + Titanium White vertical stripe).*

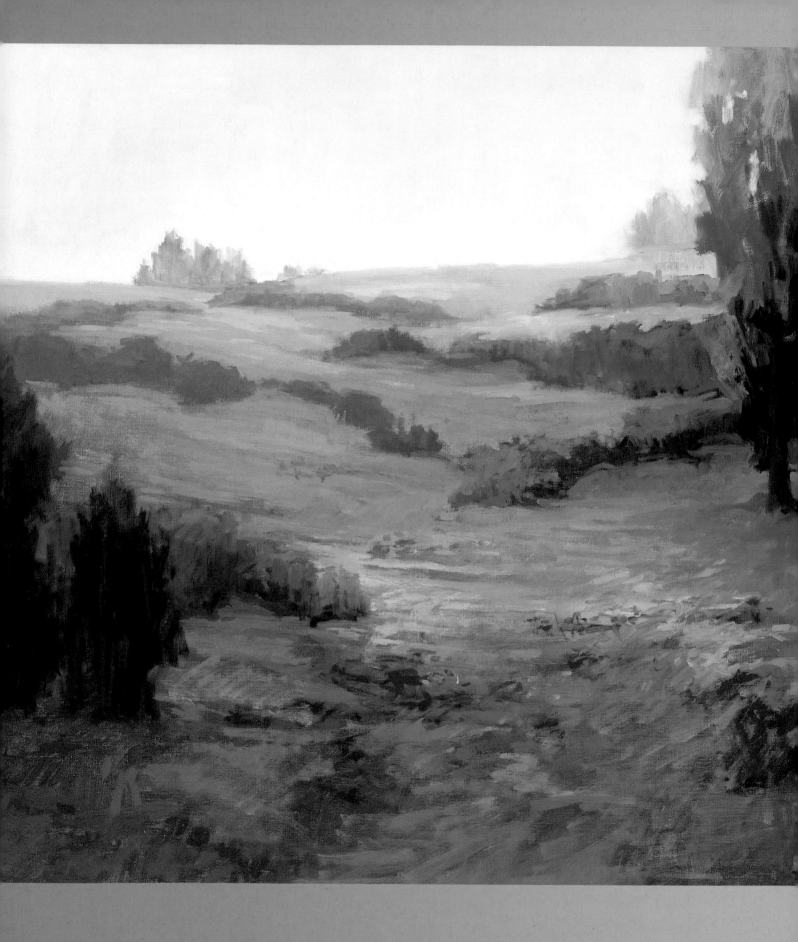

# Color
# and Design

*While expression and interpretation are driven by our experiences, design and composition are driven by knowledge. Apply this knowledge in the earliest stages of a painting's development to allow your expression to flow unencumbered.*

**Golden Hills**
30" × 40" (76cm × 102cm)

# Creating a Composition

Design begins with lines, space, and form or shapes. Use of these tools defines composition. The same design tools can be placed in a variety of areas to create entirely different compositions. You can support the center of interest by including lines and shapes to direct eye movement toward the point of interest. Shapes and lines that lead away from it or off the image entirely will considerably weaken the composition.

When I am teaching, I like to make a quick round early on to observe the students' compositions. I look specifically for shapes that enhance the subject, and I check everything from the treatment of edges to the overall positive and negative areas. I prefer to eliminate errors early: It isn't fun working our way out of major mistakes. Mistakes interrupt the creative process. Plan and think first so that you can ultimately maximize your expression.

## Intended Meaning

Composition, perspective, proportion, accuracy—these deliver meaning whether you intend them to or not.

My daughter noticed that most of my trees leaned to the left. After some thought, I realized that I normally tilt my head to the left when considering my paintings. Because I'm right handed, raising my right arm to paint tilt my head even more.

Still, these leaning trees could be subconsciously intended. Did these trees capture my true expression?

I grew up in west Texas, where the winds made life difficult. I remember leaning into the wind as I walked to and from school and imagining that if I leaned into the wind one more inch, I'd fall over or be swept off my feet. The wind shrieked at the windows and doors at night and kept me from outside play during the day.

No, I didn't want to portray the wind. As a result, I make a conscious effort to correct my leaning trees.

Save yourself some agony and review your sketch before applying paint. Look for accuracy or intent. This is the time to make adjustments.

### Drawing

During my art education in college, I worked very hard on my drawing skills. Accurate renditions are my goal, so drawing well is a necessity. Many successful artists have bypassed drawing. They choose other areas of art that fulfill their strengths and carve a niche in the art world. Therefore, I make allowances for drawing skills. Drawings can be inaccurate and still become dynamic art expressions.

### Composition and Color

The composition of a painting can be enhanced by colors, but the initial design and drawing is where the creative aspect of the painting begins.

# Subject and Color

The skills to capture form, light and value are necessary tools. Color, however, is not necessary to compose form. A black-and-white shaded drawing illustrates form very well. Light, middle and dark values tell the story of light. Knowing this, you have a lot of flexibility in choosing the color for your painting's subject.

For me, its all about lighting. The subject doesn't matter; I just need to stay faithful to the light and shadows that caught my attention in the first place. From there, I can tamper with the color and composition. I may need to tweak temperatures, values, lines and shapes to capture the right mood and meaning. A white boat perfectly lit is just another white boat, but my artistic license lets me change that boat to red.

I use the subject for reference only. I then rely on my knowledge of light, form, design and mood to fashion the subject in the manner that I choose for the expression.

*Regal Colors*

For this painting, I photographed the dancers of Ballet Austin during their pre-performance workout. I was amazed by their dedication. The deep respect they inspired in me took control of my palette. I painted in the regal colors of royal blue, burgundy and gold to play up the seriousness of this feeling. The lighthearted pastels that many people associate with ballet would simply not have corresponded to what I felt.

**Pre Performance**
48" × 48" (122cm × 122cm)
Collection of Ballet Austin

# Points of Interest

A point of interest is the inspiration point of a painting, usually an object. In landscapes, unexpected or man-made objects automatically become a point of interest. In landscapes, my points of interest often lie at the greatest distance. Such objects should be placed in a dynamic point.

There are two methods for determining where to place you point of interest;

both are illustrated below. Regardless of the method you use, you must first determine your primary, or major, point of interest. The lightest light and darkest dark values are usually found at the major point of interest. Stationary shapes are well suited as points of interest.

Next, designate two secondary minor points of interest at other dynamic points.

The designation can be as simple as repeating the color of the major point of interest in a smaller amount. Having a major point of interest and two minor points of interest subliminally creates a triangle, which is a movement shape. You generate visual movement well within the borders to keep the focus on the painting.

*Placing Your Point of Interest: Method One*
The first method is simple. Divide the overall area into thirds horizontally and vertically. This does not have to be exact; a rough division is sufficient. There will be four points where the lines intersect: These are dynamic points. Place your major and minor points of interest at dynamic points.

*Placing Your Point of Interest: Method Two*
The second method is derived from the dynamic symmetry theory, a complicated method that I'll try to simplify here. Draw diagonal lines to the rectangle's opposite corners (the dotted lines above). Next draw lines from the corners, making them intersect with the diagonals to create right angles. At these right angles, place your points of interest.

# Balance

Balance is a comfort zone for us psychologically. We feel most comfortable when we know that a structure will support our weight. Although teetering on the edge may be exciting, we will grow weary of it at some point. Precarious off-balance predicaments affect the central nervous system.

On the other hand, symmetrical placement of subjects and cleanly broken spaces can be equally irritating to the senses by appearing too balanced. Subconsciously, we are aware that very little in life is predictable. A loss of excitement is apparent in symmetrical compositions. Remember, the purpose of creating visual images is to exhibit our excitement and tell a story.

A simplified way to do this is to place a highlight as the point of interest. Begin your drawing by placing this light in a dynamic point and continue drawing outward from that specific point.

## Symmetrical Composition
A symmetrical image is centered within all the boundaries. Occasionally, this will occur. The solution to this problem is to regenerate interest by varying color and value to avoid duplication in verbatim.

## Asymmetrical Composition
An intuitive knowledge of weight and space helps when developing an asymmetrical composition. Evaluate asymmetrical renderings for balance of weight. If it appears heavy on one side and the opposite side does not balance the weight, the entire painting will appear to be falling in the direction of the weight. Solutions to this problem are adjusting values and/or adding another object to the less weighted side to achieve balance.

# Lines

Lines can be straight, curved or a combination of straight and curved. They can be continuous or broken. Broken lines add interest and offer visual relief. Lines are used to break up spaces. Avoid lines that divide spaces in equal proportions.

## Stabilizers

A stabilizer is a line that anchors objects and planes together, adding balance and defining space.

Horizontal stabilizers are the lines that add a "grounded" effect. I've frequently seen students leave out horizontal stabilizers in still-lifes; they didn't really intend for that vase of flowers to float in the middle of the painting. By painting a table surface one value and the backdrop another, you introduce that horizontal stabilizer (and add some depth). These lines don't need to cross the entire width of a painting; a mere suggestion works.

A vertical stabilizer is used to give energy to images that are totally horizontal. A painting with repetitive horizontal planes can be too linear and might lead the eyes right off the painting. Introducing a vertical stabilizer can prevent that. A tree can act as the vertical stabilizer in a horizontal landscape.

Diagonal stabilizers represent movement and distance. The diagonal element can add a great deal of energy to a painting. If there's a strong, distinctive diagonal, though, this energy can also lead the eyes right off the image. Countering with a lesser diagonal helps prevent this.

*Lines and Edges*
Check the intersections of lines along the edges of paintings. Unequal intervals are preferable.

Horizontal lines near edges should be perpendicular to the edges or slightly upward or downward. Any strong upward or downward line will pull the eyes off the canvas entirely. Closing the value gaps or using of transition colors eliminates hard lines near the edges.

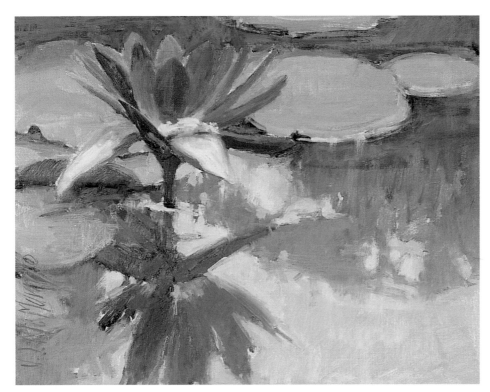

### Lines as Stabilizers

The row of lily pads and the dark water behind them are the horizontal stabilizers. The water lily is the point of interest. The yellow center is at a major dynamic point. The darker version of yellow reflected in the water underneath the bloom and the gold toward the upper right are in additional dynamic points and become the two minor points of interest. The reflected dark patterns in the water are abstracted.

**Enjoying the Sun**
11" × 14" (28cm × 36cm)

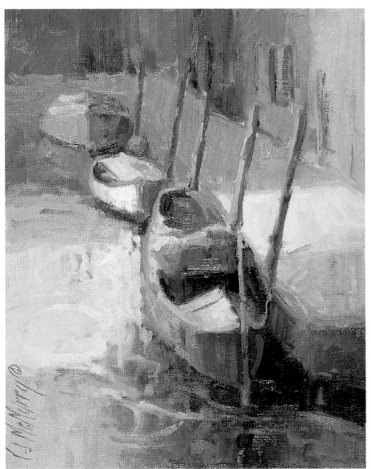

### Neutralize Strong Diagonals

The three boats create a strong diagonal. The poles counter the main diagonal by acting as minor diagonals. Strong diagonals can lead vision off the painting unless they're neutralized with a counter diagonal.

*Venice Cove* needed additional strength and tension, so I countered the horizontal line leading into the painting on the upper left edge with a horizontal line opposite the lead-in on the lower right edge. This creates an imaginary diagonal and subliminal visual tension between two points.

The light falling across the water and sidewalk create a subtle horizontal stabilizer.

**Venice Cove**
14" × 11" (36cm × 28cm)

# Shapes

Shapes are a crucial element in visual work. I conceptualize my compositions in terms of shapes and manipulate them in ways that have a dramatic impact. There are two basic types of shapes, stationary and movement. Generally, shapes with regular, equal portions, like circles and squares, are stationary shapes. Shapes with exaggerated or elongated proportions, like triangles and rectangles, are considered movement shapes.

## Stationary Shapes

Stationary shapes are ideally placed in dynamic points. These shapes force our visual journey to stop. Extreme values, hard edges and the color red magnify visual intensity. This is a powerful visual manipulation of the audience. It is a subliminal message that says, "Go here. Look at this. Stay a while." It commands attention.

By elongating or exaggerating the proportions, you can alter a stationary shape to suggest movement. An ellipse is a movement form of a circle. An ellipse can add width or height direction. You can also alter a stationary shape without suggesting movement; I do this to add complexity to a composition and interest to an otherwise blunt shape.

## Movement Shapes

Movement shapes are vital for guiding the eye in and around a painting. They create

*Stationary Shapes*

### Stationary Shapes at Dynamic Points

In *The Bird Lady*, the round red hat definitely required placement in a dynamic point. I began my sketch with the circular hat and drew outward, emphasizing the round shapes of the seated figure. I repeated the red color twice more, using a very pale version for the light on the rocks and the ducks' beaks. I also used darker muted reds in the rock shadows. Had the red hat been the only red in the painting, it would have demanded too much attention. The rest of the painting would be ignored.

I also placed the woman facing "into" the painting. If she had been looking "off" the painting, the eye would follow her gaze off the painting.

**The Bird Lady**
11" × 14" (28cm × 36cm)

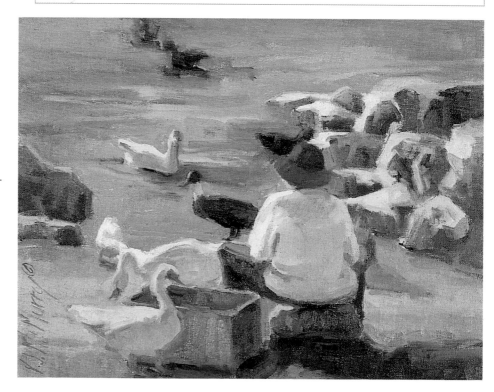

a path to the stationary shapes or spaces, which are placed in dynamic points. I use movement shapes for lead-ins into paintings.

Direct movement shapes tell a short story; they say, "There it is." Indirect or altered movement shapes tell a longer story. They say, "Come in. Stay a while. Enjoy. Relax. Ah, there it is."

Generally, I prefer the use of altered shapes. In fact, I'm very fond of altered

and broken shapes. I like the indirect or broken path to a house, bumps in the land or ripples in the water. They represent small hurdles or challenges in life.

## Negative and Positive Shapes
We usually compose an image around the objects themselves (positive shapes) but the space between these—the negative spaces—are equally important in composition. A small negative space between

two positive objects creates a tension that demands attention. A large negative shape in an area releases the visual tension created by positive shapes and causes us to relax. You can incorporate stationary shapes and movement shapes into your painting using negative space.

*Movement Shapes*

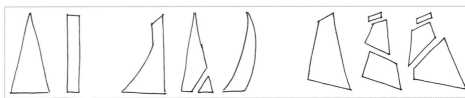

*Altered Movement Shapes*
These movement shapes are exaggerated, broken and altered to bring interest and subtlety to a painting.

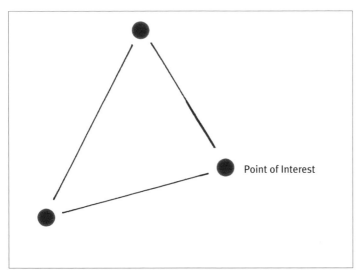

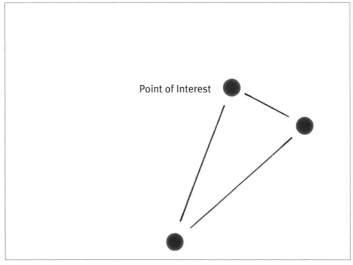

*Subliminal Movement Shapes*
Our eye travels in a triangle between the three spots of the same color. As a triangle, the negative shape is a movement shape.

# More Shapes

### Overlapping Shapes

Overlapping is a wonderful method for creating unique and interesting shapes. Start simple. Build various overlapping shapes. This is a great way to search for your distinct design style.

### Shapes Within Shapes

For trees, I usually pick a master shape, like a trapezoid. I block in the master shape with the local color then I let the brushwork add additional shapes within the master shape. By doing this, I let the painting guide me.

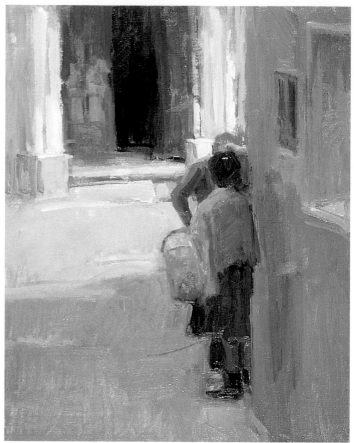

### Small Shapes and Large Shapes

The point of interest in *Corner Encounter* is the contact between the heads of the figures. The painting focuses on the communication between two people randomly meeting on the street. The smaller shapes are concentrated at this center of interest. The surrounding areas are simply large planes of color with no real detail.

**Corner Encounter**
14" × 11" (36cm × 28cm)

### Odd Numbers Work Best

An odd number of subjects is best in compositions. I painted three children playing in the water in *Three Buddies*. For composition purposes, I grouped them. The two boys on the right are close together but not overlapping. The third boy is set apart. Notice the spacing variety of negative areas. The boys are all looking into the painting. They are different sizes with different clothing colors. Because red dominates, I placed the red shirt in the two right dynamic areas. A short wave is the horizontal stabilizer.

I have, on occasion, use two subjects. My theory is that we live in a society of couples. Two subjects are a reminder of the bond between two people. I recommend grouping or overlapping the two subjects, forming the impression of unity.

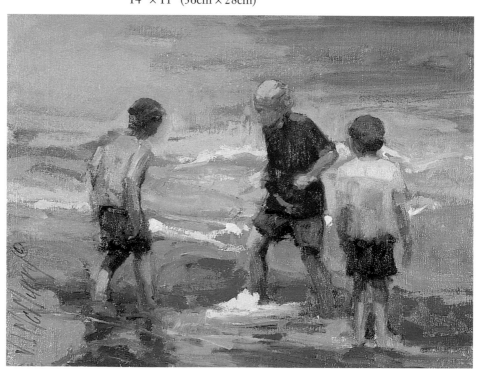

**Three Buddies**
11" × 14" (28cm × 36cm)

# Diptych Composition

A diptych is made up of two paintings that can be placed side by side to create a single image. They may be separated and hung independently, in which case each image needs to be self-sufficient. They need to each be well orchestrated and bring each other to a different level when placed together. The composition should include points of interest individually and as a pair.

Diptychs must be formatted similarly as either horizontal companions (same height required) or vertical companions (same width required). *Red Refinement* and *Radiating Reds* are two vertical paintings. When grouped together, the image becomes horizontal.

The same rules apply for triptychs—three paintings hung side by side to create one image.

**Red Refinement (left)**
30" × 24" (76cm × 61cm)

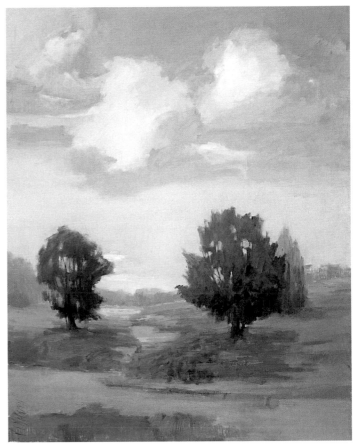

**Radiating Reds (right)**
30" × 24" (76cm × 61cm)

### Design and Diptychs
Most artists treat diptychs as one painting and design accordingly. I prefer to think of each section as an individual painting; this method allows each section to be sold separately. I begin with two canvases on the easel and sketch as if they are one canvas. Once the sketch is finished, I look for each section's unique points of interest to enhance while I paint.

# Placing Color

Even now that I am a mature artist, my methods are directly influenced by my inner child. In my quest for authentic expression, I've found her voice to be immediate, genuine and reliable. When it comes to the placement of color, she rarely steers me wrong.

## Broken Color

I refer to the process of breaking a color into smaller segments with additional colors as broken color. The result is similar in effect to a kaleidoscope. This method can really energize artwork.

When you use broken color, look at the different attributes of the color wheel. I am notorious for alternating temperatures throughout a painting. I find that alternating temperatures can add more sparkle to light or dark areas. The contrast of warm colors near cool colors adds interest to a painting. You can also alternate values and saturation.

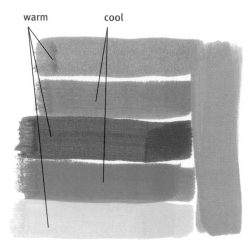

*Alternating Temperatures*
By alternating the temperatures, you can add sparkle to the colors. The vertical band of dull color above consists of all the horizontal colors mixed together. Notice how the mud intensifies the brilliance of the original colors?

*Broken Color Examples*
Broken color follows the same concept as broken lines. Use of broken colors adds excitement and energy.

Clockwise, from top left: same value, different temperature; same temperature, different value; random colors; and pure pigments, gray pigments.

*I cropped my photograph to incorporate a dominant shaded area. Although the side of the boat is white, white does not work in the shaded area. To add some punch, I used a grayed Phthalo Green. It glows next to the muddy colors. This spot of reflective light led to my next decision. I used Phthalo Green + Titanium White for a highlight in the water directly beneath the highlighted white area of the boat. The location of this highlight is a dynamic point. The stroke of magenta along the line where white and black meet creates an unexpected thrill.*

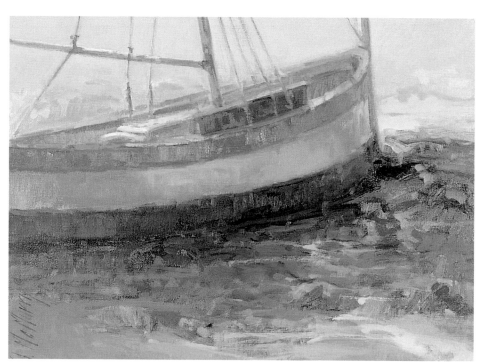

*Broken Color: Saturation*
My focus during this painting remained on maintaining sparkle in the dark areas. I painted back and forth using pure colors and grays. Each time I reversed my pigments, I let some of the other colors appear under and between the brushstrokes, breaking up the color. Too much intense color in this area will not read correctly, so alternating pure and gray colors was the way to go.

**Shadow Patterns**
14" × 18" (36cm × 46cm)

## Isolated Color

When a color is isolated in a painting, it increases the tension. As social beings, people want to be connected with each other. An isolated color appears unconnected. Eventually, the eyes, weary of the tension and the emotional loneliness it portrays, leave the painting.

An isolated color situation can be solved by repeating the hue in a different value or temperature elsewhere in the painting. If you have an area of Cadmium Red Light, you might sprinkle some cooler Alizarin Crimson throughout the painting.

*Life At the Edge*

Refrain from drawing attention to areas near or at edges. This pulls the viewer's focus off the painting.

*Echoed Color*
The purples and oranges could have been isolated colors in this painting, but pulling these colors into the clouds and shadows added a feeling of connection. These echoed colors help the eyes travel through the painting.

**Loose Interpretations**
11" × 14" (28cm × 36cm)

# Color Thumbnails

We can determine the color equation for a painting with the use of thumbnail color sketches. These are small sketches of flat color that really simplify a composition into patterns of color, rather like a blueprint for color and design. I keep my color thumbnails simple. Generally, I limit my colors to the primaries, but sometimes I branch out to yellow, orange, red, purple, blue and green.

This reference helps us see the balance of color and design. I use a color thumbnail if a painting feels like it's moving off the path I'd intended. If I suspect the pattern of colors isn't working, I create a simplified color thumbnail. If the color scheme was the problem, a color thumbnail will show that clearly.

You can also use color thumbnails before painting for much the same reason; a color thumbnail will eliminate a lot of distraction and prevent problems.

### Is It Working?
In *Orange Glow*, the lightest value is orange, and the darkest value is red. I tried several times to lighten the orange glow on the top left cloud. Each time, I'd end up bringing the value back down. I finally decided that my mood was in control. I let the painting happen. When the painting was complete, I created a quick color thumbnail (at right) to examine the painting.

**Orange Glow**
12 × 9 (30cm × 23cm)

### Format Issues
The first incorrect item that I noticed was the design of *Orange Glow*: The purple clouds break the painting into thirds. One solution is to rework those clouds. Another solution is to reformat the image size. If you hold your hand so that it covers the top third, the composition looks more balanced. I prefer the second solution (but that may be because I'm partial to square paintings). I can now use this painting and the thumbnail as guides to paint *Orange Glow* larger and square. I have a blueprint that I know will work.

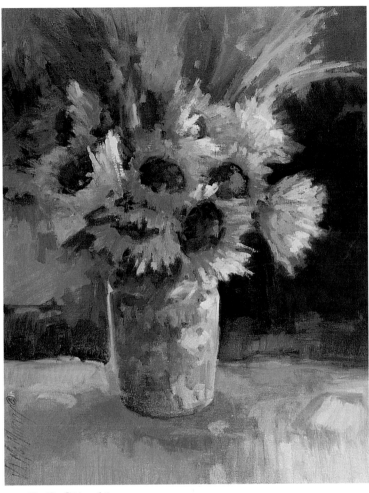

## Is It Working?

I began this design by placing the vase slightly off center, which put several sunflower centers at points of interest. The round, stationary sunflower centers worked well there, holding the eye rather than leading it out of the painting. My first choice for the background was purple, yellow's complement, but regardless of which value or temperature I used, purple didn't work. I tried another approach.

Because the flowers are in the yellow family and the vase is in the blue family, I decided to try cool reds in the background. The coolness recedes next to the warmth of the yellows. By adding the cool reds, I managed to incorporate all of the primaries, too.

**Sunflower Splendor**
18" × 14" (46cm × 36cm)

## Color Issues

What I want for this painting is unequal masses of colors. As a general rule, the viewer's eye naturally seeks out variety. A painting that's one third red, one third blue and one third yellow would be repetitious and uninteresting. The thumbnail indicates that I have a nice variety of color distribution.

# Transition Colors

Transition colors are hues or values that blend masses together. The most common use of transition colors is to soften hard edges.

Our eyes can focus on one focal point at a time. Items in the focused area should be clear and distinct with hard edges. Everything outside of the focused area is our peripheral vision, which is blurred. You can test this by focusing on a single item in the room. Do you notice the blurred vision outside of the focal point?

Because of this phenomenon, it's a good idea to have the most dramatic value contrast and hard edges at the center of interest in a painting. If you adhere to this rule and apply it, you'll prevent unnecessary visual stress on the painting's viewers. Make it a pleasant experience to look at your work, as this is the way the eyes normally see. Hard edges everywhere in a painting are too visually demanding.

## Blending Masses

With a transition color, the goal is to ease the hard edges by blending where two subjects meet. The simplest way to do this is to pull the adjoining colors together. For example, if trees overlap the sky and they don't share color at the edges, they just look like cutouts pasted to your painting. To join the two subjects, mix some of the sky hue with some of the tree hue and use this toward the tops of the trees where they meet the sky. This should soften the edges just enough. Painting wet into wet is an easy method for blending adjoining colors.

Another example is the harsh line created when the dark vertical trees meet the light horizontal land. Again, mixing some of the tree hue with some land hue and painting this mixture where the two planes meet softens the hard edge.

Once I understood transition colors and tried them out in my work, I fell head over heels for it. Because of who I am, I find the harshness of hard edges difficult to paint, even at the point of interest.

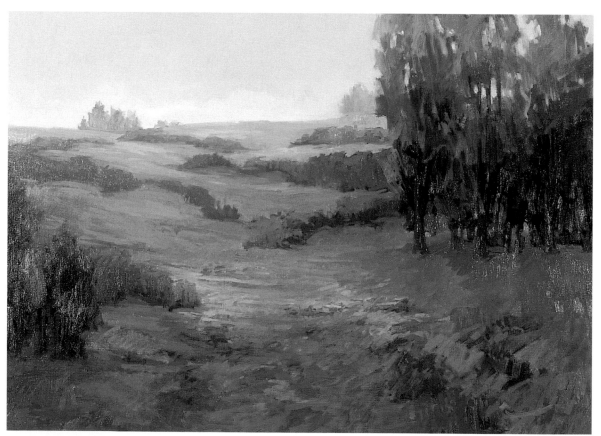

*Pull Color Areas Together*
To create some transition colors in *Golden Hills*, I added the bluish sky mixture to my greens for the distant trees and to my yellows for the distant fields. Choosing the muted blue of the sky was a practical decision because the atmosphere in the distance is seen in hues of blue or gray. I also used the sky mixture to lighten the large foreground trees on the right. I softened the edges below the hedges by blending the hedge colors with the land colors and painting this color where the edges meet.

**Golden Hills**
30" × 40" (76cm × 102cm)

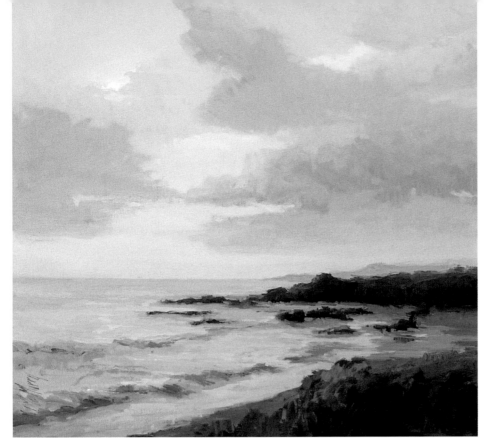

## Transition Colors Everywhere

The surface of the water reflects light from the sky. To make the reflective lights, simply mix the sky colors with the mixtures for the water. I softened the horizon line of the water by mixing the nearest sky colors with the nearest water colors. I combined the lightest yellow in the sky with the muted purples in the clouds for the light edges of the clouds. The jutting vertical land mass is joined to the horizontal land by combining adjoining colors. By mixing colors into each other on your palette, you are automatically create transition colors.

**Silent Waters**
28" × 28" (71cm × 71cm)

## Soften Hard Edges

The edges of the red field of flowers are softened by combining the surrounding greens with the reds. The sky is normally the lightest light, and vertical trees are normally the darkest dark. That value change creates hard edges. I pulled the blues of the sky into the tops of the trees to soften the edges.

**Path to Peace**
40" × 30" (102cm × 76cm)
Collection of Vicki Oswalt

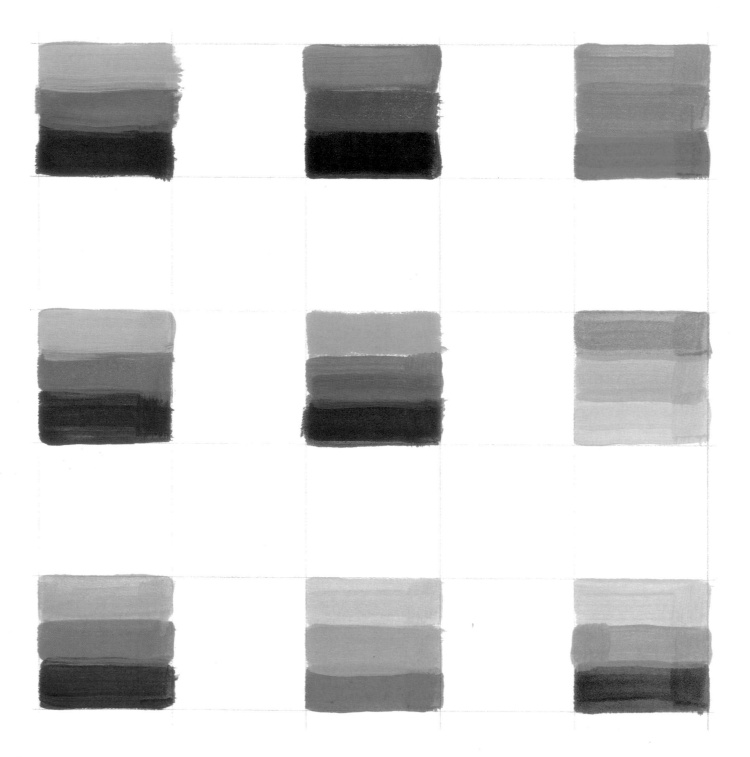

### Creating Transition Colors

To create the transition colors (the middle bands) in the chart above, I mixed the two outside colors together. Notice how the transition colors soften the otherwise hard edge. The transition color also blends and unites the two colors. It forms a relationship between colors.

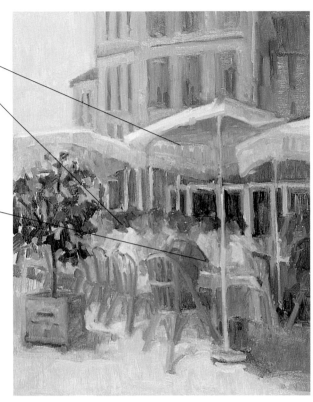

Edges softened

Masses blended

Stronger value contrast and harder edges become center of interest

## Develop the Transition Colors

Transition colors should naturally present themselves in the beginning as you mix colors to create the appropriate colors and value colors. Begin developing transition colors by mixing into your first darks.

I painted the red shirt in pure pigments and left it alone as a reminder that the red shirt is my point of interest. I moved some of the red tones to the underside of the umbrella. The light from the sky added a glow to this area, and I intended to reflect the red shirt up to this area.

## Use the Transition Colors

Here, I adjusted the values on the far right side of the building. I decided to use the sky mixture to maintain color harmony across the painting. Once I determined the sky's value, I was able to create a darker version of that for the shadowy side of the building.

I popped the light on the umbrella tops with some of the sky mixture + Cadmium Yellow Light + Titanium White. By using some of the sky mixture, I created a transition color that ties the sky, buildings and umbrellas together.

I kept the sky area flat. The painting has a lot of busy areas and the sky is the visually designated resting area for the eyes.

**Café Crowd**
18" × 14" (46cm × 36cm)

*The red shirt would be isolated in "Café Crowd" and become more of a distraction if the color red did not appear two more times in the painting. This creates a triangle, which is a movement form.*

*The bright white shirt was also isolated. White does not draw visual attention as much as red does. It seemed logical to bounce the white over to the red shirt to bond two distinct areas of attention.*

## Toning the Canvas

I toned my canvas with Alizarin Crimson. I mixed three values of a gray made from Ultramarine Blue + Cadmium Orange. I blocked in the painting with pure colors and then overpainted with the three values of the gray. Not only do the pure colors pop through the grays, but I was also able to avoid a chalky painting.

# Corners and Color

When I step back from a painting in progress to check it, some of the first items I check are the temperatures and values in the corners. I like to make sure that my paintings have three corners of one value and/or temperature and then one corner that is a different value and/or temperature. The theory behind having one distinctively different corner is that this gives the viewer a way in. Applying this 3:1 ratio also helps you avoid the problems associated with having four corners the same:

- Four dark corners "trap" us. Our attention bounces from one corner to the next with no relief. We have an innate desire for freedom.

- Four light corners make the painting appear airborne and lack support. The eye travels out of the painting at every corner. We don't feel grounded.

- Four corners similar in color or temperature become monotonous. We feel bored.

Applying this corner theory to your work will also alleviate some common design problems.

It isn't always possible to set up a still life or find a landscape where the 3:1 occurs naturally. In this case, you need to force the change. The most flexible option is to change the temperature of a corner rather than the value.

## Eye Movement and Corners

It's your artistic license to determine the fate of the corners, but there are some psychological nuances involved. How our eyes move depend a great deal on how we read. In the West, we read from left to right, starting at the top and working our way down. Because of this, Western art theory traditionally taught students to use the inverted 6 (see figure B).

Global communication, trade and finance have broken barriers and blended cultures. You have a lot more flexibility of where you place the "odd" corner because of this. Where the odd corner falls now depends entirely on the needs of the painting.

figure A

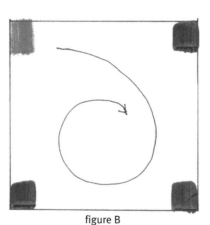

figure B

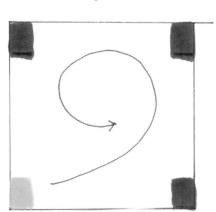

figure C

figure D

### *The Corner Entrance*

In each of these examples, the eyes enter through the odd corner. The three remaining corners block the eyes from leaving the image. The 6 and 9 patterns—including the inverted versions—are similar to a nautilus shell. Once the eyes are led into a painting, blocked from exiting, they will circle the image concentrically until they reach the point of interest. Our senses digest the information before losing contact.

The top two figures rely on temperature. The viewer's eye enters through the warmer (and lighter) orange corner and then travel around the painting. The bottom two figures show corners of the same color with different values. Here, the eye enters the painting at the lightest corner.

**A** 3 cool: 1 warm creates a 6 eye movement pattern.

**B** 3 cool: 1 warm creates an inverted 6 eye movement pattern.

**C** 3 dark: 1 light creates a 9 eye movement pattern.

**D** 3 dark: 1 light creates an inverted 9 eye movement pattern.

## Corner Variation

*Sparkling Silence* has three cool corners and one warm corner. In this case, the entrance is at the warm corner on the lower left.

The sky shows lots of value and temperature changes, as well as a variety of hard and soft edges. The same is true of the water. Choppy, horizontal brushwork indicates some current in the water. The linear clouds and trees frame the point of interest, the sun. The light reflecting in the water, the lighter green on the right bank, and the sun form a triangle within the painting.

**Sparkling Silence**
20" × 30" (57cm × 76cm)

## Unite Horizontal Planes

*Engulfing the Light* has three cool corners and one warm corner. You could also read it as having three light corners and one dark corner. The entrance to the painting is at the warm, light corner.

Midday paintings have less drama than early morning and late afternoon paintings because the light at midday is relatively flat. The shadows are directly beneath the verticals, which makes it difficult to connect the darks. I forced the darks darker, and I angled the light source slightly to the right.

**Engulfing the Light**
9" × 12" (23cm × 30cm)

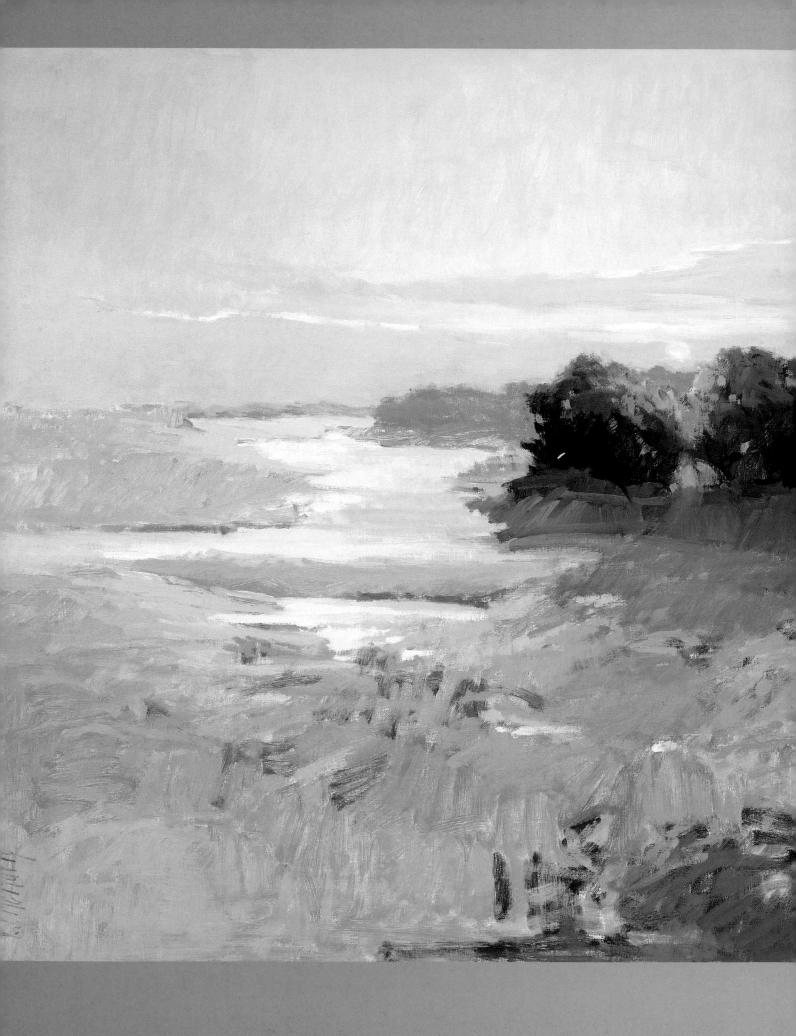

# Color on the Canvas

*When they were young, my daughter and her friend used crayons to convert a white wall into a splendid "work of art" (total chaos, really). If it had been our house, I would have left their work of art on the wall and enjoyed it for years. Unfortunately, it was not our house—and we were never invited back again.*

*Some people fear a blank canvas; it represents the possibility of failure. Keep in mind that all art is valid, so creating anything is good. Go ahead and put that first mark on the wall.*

**Melodic Meadows**
24" × 30" (61cm × 76cm)

# An Easy Choice

Few things in the life of an artist are more exhilarating than recognizing a worthwhile subject, but you can't always stop to paint it. Fortunately, we have cameras to help us gather as many of those missed painting opportunities as possible.

I rummaged through my pile of photos and found a few with potential. I decided to use a sunset at the beach; it has very strong design possibilities, nice patterns of light and dark, and rich colors.

A warm opaque red was the dominant color in the photograph. This color, along with the supporting colors, inspired me to paint this scene. I was able to cover the full range of values and temperatures with only six colors. This limited palette kept the color notes related.

Keep in mind, though, that photos are a resource. Painting an exact duplicate of the photograph robs us of our personal expression. I keep my photograph handy while blocking in a painting, then I set it aside and refer to it only if a problem occurs. Otherwise, I would be tempted to paint the photograph as is.

## Colors Used

- Ultramarine Blue
- Cadmium Red Light
- Cadmium Orange
- Cadmium Yellow Light
- Titanium White
- Alizarin Crimson

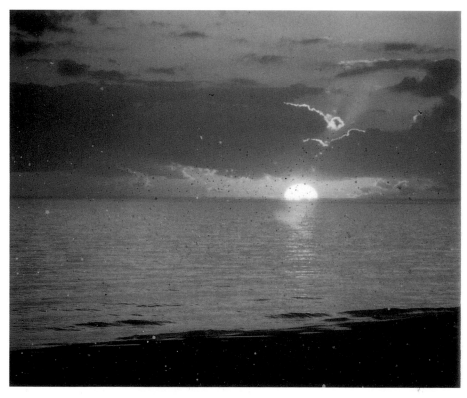 

## 1 Decide on a Format

I had several choices with the horizontal layout. The sun could have been placed on any of the four dynamic points. The vertical format had as many options. That's eight different choices before I even started painting. When you consider the range of color choices available, you could probably paint an entire exhibition's worth of paintings based on a single photograph.

I finally made a choice and cropped the photo to place the sun on the upper-right dynamic point. I preferred that positioning so that I could include the wonderful dark foreground. Generally, I use drafting tape to crop my photos. It has less adhesive than other tapes and removes easily. Here, I've cut this photo for an easy visual reference.

With a strong design such as this, the painting process is spelled out. All I have to do is mix colors and then paint.

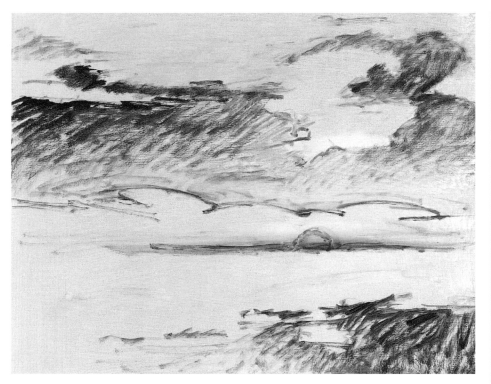

## 2 Set the Design

I toned the canvas with a thin wash of Ultramarine Blue + Cadmium Red Light, wiping off any excess turpentine. I used a darker version of that mixture to sketch. There is very little to sketch for this painting, but it's important to place the sun on a dynamic point. Using a no. 2 bright bristle brush, I sketched in some values. I always try to take extra time to get the drawing right at this point. The surface was still wet with turpentine, so erasing was easy—I simply rubbed with a cloth or paper towel.

At this point in the process, check the design and don't move forward until you're completely satisfied. The design is the foundation; the rest of the painting depends on the strength of this foundation.

*I will struggle less with a painting if I make decisions now. During this phase, I'm already aware of how I'll handle the corners. For this painting, I chose to have one dark corner in the lower right. To make the lower left corner light, I eliminated the dark beach, replacing it with water. This painting already had three strong horizontal lines, and the reshaped beach will pull the eyes into the point of interest, the sun. Because I was drawn to the wonderful, amorphous cloud shape in the sky, I decided to use it as a minor point of interest.*

*At this point, I've also decided where to place my values. The lightest lights are the sun (the point of interest), the sun's light reflecting off the water and the backlit wisps of the moisture above the clouds.*

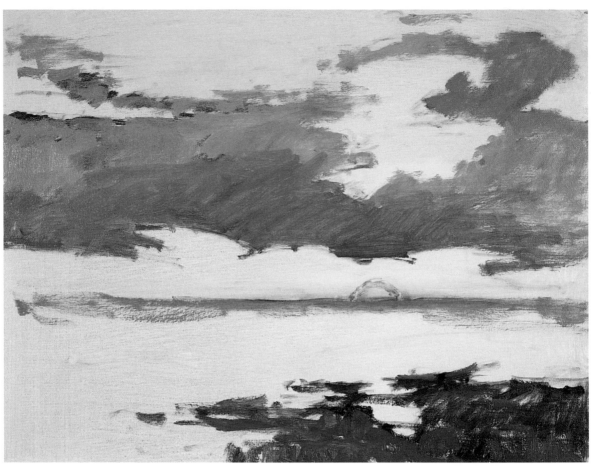

### 3 Begin Laying In Colors

The two predominant primary colors in the scene are red and blue, so I used a basic mixture of Ultramarine Blue + Cadmium Red Light to block in the painting.

In the darkest dark—the land, in this case—I kept the mixture on the blue end of the spectrum, adding just enough Cadmium Orange and Cadmium Yellow Light to make subtle variations in the land.

For the clouds, I brought the mixture toward a burnt orange by adding Cadmium Red Light + Cadmium Orange + Cadmium Yellow Light. For the gray areas in the clouds, I used a little of the land mixture and add more Ultramarine Blue + Cadmium Yellow Light + Titanium White.

At this point, the scene's horizontal lines were very apparent, almost overpowering. To ward off the monotony, I broke up the lines with random curves of the land that stretches into the sea.

*I am exaggerating on the dark side of the values because I like to have lots of room to come up to the light. I also like to scumble lighter values over the dried darks. The undercolor will enhance the lighter values and help avoid the chalky effect. I can illustrate the illusion that clouds are not solid masses, and I can keep the edges soft where needed.*

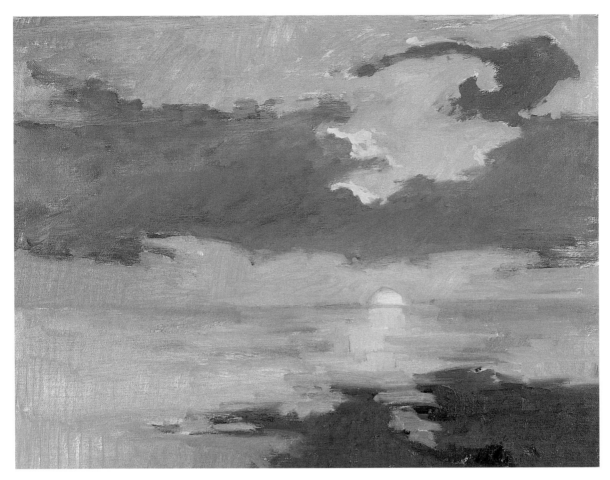

# 4 Cover the Canvas

I used the mixtures from step three separately and mixed together to create additional values and temperatures. I lightened the mixtures with Cadmium Yellow Light or Cadmium Orange + Titanium White, and I darkened them with Ultramarine Blue and Alizarin Crimson.

I started with the sky. Near the sun, I kept the color on the yellow side. On either side of this, I leaned the color toward orange. I used a soft red version as the sky approaches the edge of the canvas. As I painted upward in the sky, I cooled the colors to indicate distance from the sun. I darkened the sky values to make an intense reddish orange glow for the clouds. I feathered my brush over the grays to soften any harsh lines in this area. Then I mixed Ultramarine Blue + a little Titanium White back into this red-orange mixture to mute it. I used this muted mixture to repaint the grays of the clouds, feathering again into the red-orange glow.

For the water, I added more Ultramarine Blue and Titanium White to the original Cadmium Red Light + Ultramarine Blue mixture. I painted this over the water, but left untouched areas where the sun will reflect off the water.

I scraped all of the dark mixtures on my palette together and used this as a base for the land. I darkened this mud further with Ultramarine Blue + Alizarin Crimson to paint the land. As I painted over already painted parts, I let some of the underlying color show through to create a few abstract areas.

I scraped together the light mixtures and created two mixtures for highlights, adding Cadmium Yellow Light + Titanium White to one and Cadmium Orange + Cadmium Yellow Light + Titanium White to the other.

For the sun, I painted a big dab of Titanium White and then gingerly glazed some thinned Cadmium Yellow Light + Cadmium Orange over the white dab.

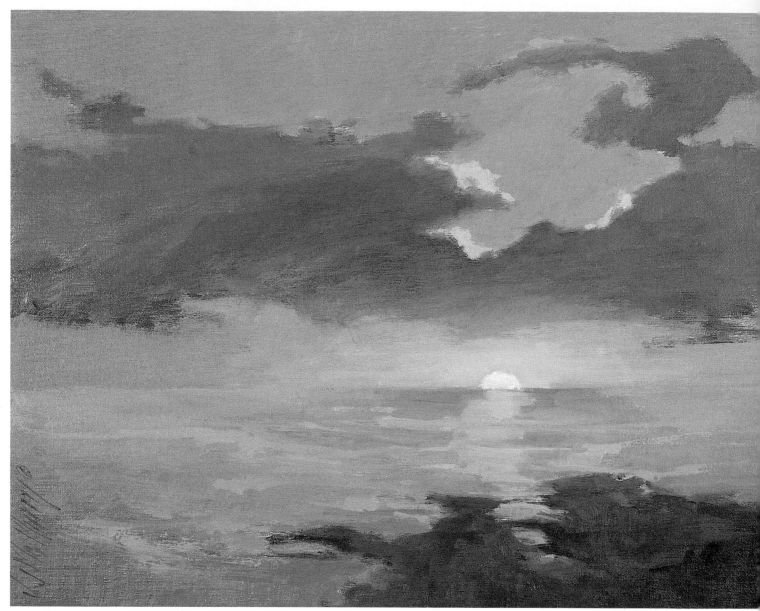

**Rapture**
14" × 18" (36cm × 46cm)

## Check Values Digitally

A digital camera is an excellent way to check your painting's values. Simply set your digital camera to the black-and-white and take a picture. It will be easy to tell if all of the value planes are working.

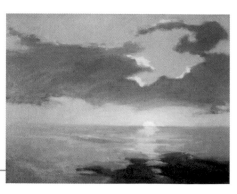

# 5 Make Any Final Adjustments

When you've reached this stage, it's critical to make a list of areas you intend to adjust. Otherwise, you'll find yourself repainting everything.

In this case, I wished to add more glow to the underside of the clouds. I did this by adding more Cadmium Yellow Light + Cadmium Orange to the cloud mixture and scumbling it over the prior paint. I softened the line at the glow by scumbling over it.

I varied the values and shapes in the land by painting it with some of the red cloud mixture from step four. I moved the color around, darkening the mixture for contoured areas.

I popped up the sun and darkened the reflections. I dabbed the sun again using very thin Cadmium Yellow Light. I also scumbled a lighter version of the clouds and a darker version of the sun in the water for the reflections.

Everything interesting is happening on the right side of the painting, which weighs the image to that side. To counter this, I added a very minor point of interest in the water on the lower left. While it isn't in the photograph, this light encourages the eye to move through the painting.

I decided to keep a harder edge by the center of interest, but softened the water's horizon line away from the sun. My clouds became more orange than red, so I used a mixture of Ultramarine Blue + Cadmium Orange + Titanium White to soften the horizon. Naturally, this color needs to be moved around the painting, so I used it for the reflected light on the waves. Artistic license grants me the right to manipulate the image to maximize the effect.

# Final Analysis

The colors, design and treatment of the corners, lights and darks all have appeal. My color mixtures are all based in the primary colors of my palette. Because every color is can be created from the primary colors, I could have taken this painting to read yellow, orange, red, purple, blue or green. In *Rapture* the only color that is truly absent is green. The mood is definitely subdued by incorporating Ultramarine Blue in areas. Adding Ultramarine Blue to the cloud mixtures soothed the temperatures so the sky seemed warm rather than hot.

## Corner Theory

The odd corner works. The eye enters at the lower right, follows the light reflection of the sun to the center of interest (the sun) and then travels to the backlit clouds.

## Broken Color

The sun's reflection provides broken color and the sense of movement.

## Hard Edges

The design places the harder edges along the horizon by the center of interest.

## Contrast

There are a variety of values and temperatures in the clouds and land. Value and temperature contrast between the water and the sky also focuses the point of interest. Purer, more saturated colors are located around the center of interest, too. The muted colors support the center. The light of the setting sun really dominates this painting; its warm rays flavor the entire scene.

I am a firm believer that the block-in will dictate each decision thereafter. The painting will talk to you and tell you what to do next. The colors I chose to block in this painting determined the entire theme. I could have easily chosen different dominant colors in the block-in, but the result would have been entirely different.

If you feel lost in a painting, the problem or problems probably surfaced in the very beginning. You can force a painting off its initial path, but that involves some struggle. I let the photograph and color choices set the stage for an easy painting. I challenged only the design and made it work.

# A Difficult Choice

There is no doubt in my mind that a proficient plein air painter could paint the scene in this photograph with ease. Such a painter is used to painting lots of greens in half values. I'll get to the point: I struggled with it. The only good news is that I know why I struggled and at which point I began my descent. It all began with the corner theory. For some unknown reason, I was determined, even stubborn, about using the zig-zag design approach: entering the painting bottom left, moving up the bushes, across the path up the roofline to the large background tree.

The next major problems that I created for myself include changing the direction of the light, changing the overall temperature from cool to warm and changing the hills. You get the picture. I selected this photograph for the memories and then proceeded to change everything about it.

## Colors Used

Titanium White
Cadmium Yellow Light
Cadmium Orange
Cadmium Red Light
Alizarin Crimson
Platinum Violet
Ultramarine Blue

## 1 Select a Format

I cropped this photograph so that the buildings were in the top two dynamic points. I'm already thinking ahead here: I want the tops of the bushes to be the primary point of interest and the right building to be a secondary point of interest. I know that I want to include some sky. I have not decided on a color scheme at this point.

## 2 Set the Design

Selecting the color to tone the canvas can and will set your approach to the painting. For this painting, I wanted the overall image to exude warmth and friendliness, so tone the canvas with a thin wash of Cadmium Orange. Always wipe any excess turpentine from the canvas.

I drew in a faint diagonal line with a very light, thin mixture of Platinum Violet. This helps in placing the dynamic points on the canvas.

For sketching the image, I used Cadmium Orange + Ultramarine Blue (thinned). I used the brush like a pencil to sketch the values, but left lots of strokes to use later on for abstracting within shapes.

*Since every decision leads to the next, the color you use to tone the canvas will have an effect. If you are a realist, tone the canvas with the dominant color of the scene. If you are an impressionist or an expressionist, tone with various colors at a whim to explore your expression.*

## 3 Block In the Shapes

I must have been impressed with the brownish sketch, because I chose an earthy sepia color mixed from Ultramarine Blue + Cadmium Red Light + Cadmium Yellow Light as my base color. For the greens, I used less Cadmium Red Light in the mixture. I added more Cadmium Yellow Light to my mixture for the foreground (to bring it forward), more Cadmium Red Light for the middle ground and more Ultramarine Blue for the background (to push it back).

I painted all of the verticals and slants. To vary the values, I mixed Titanium White or Alizarin Crimson into my mixtures.

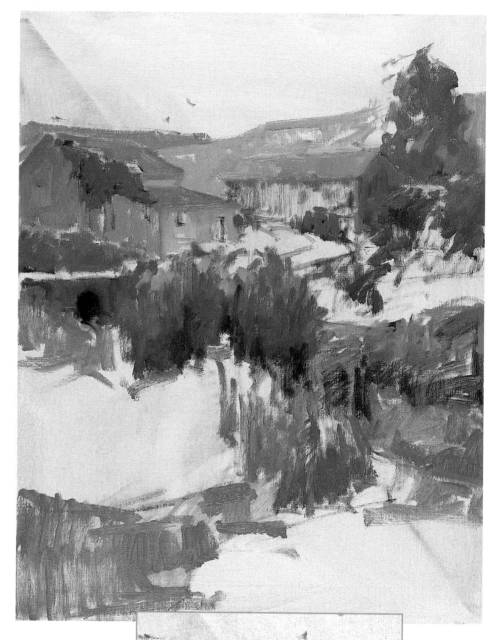

*This detail shows the harmony among the colors. It also shows one of my first mistakes. I liked the color combinations for the bridge and tunnel. I remember thinking that this dark is too dark for its location in the painting (it split the painting in half), but I liked the color so much I ignored the thought. (Did I mention that I'm stubborn at times?)*

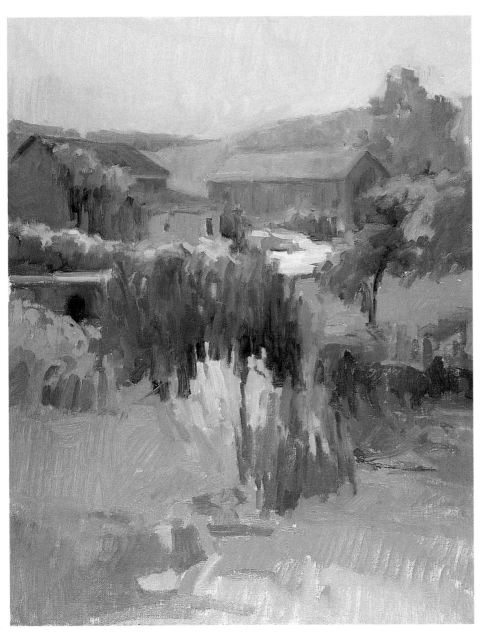

## 4 Cover the Canvas

I remained steadfast about mixing the original color scheme of the three primaries. I incorporated Cadmium Yellow Light into the foreground, Cadmium Red Light into the middle ground and Ultramarine Blue into the background.

The light in the resource photo was somewhat diffused because it was an overcast day. I changed the light to full sun. My point of interest in this painting is the group of flowers. By changing the sunlight, I could darken the value of the building. The darker building sets the foundation for popping the lighter-valued flowers.

The dominant color in this painting is green. Since I like how the purple family works with green, I loaded the large middle bush with lavenders mixed from Platinum Violet and Titanium White.

*At this point, I struggled to find a variety of green values and temperatures for the foliage. Some of my struggle arose because I'm not normally drawn to dominantly green landscapes.*

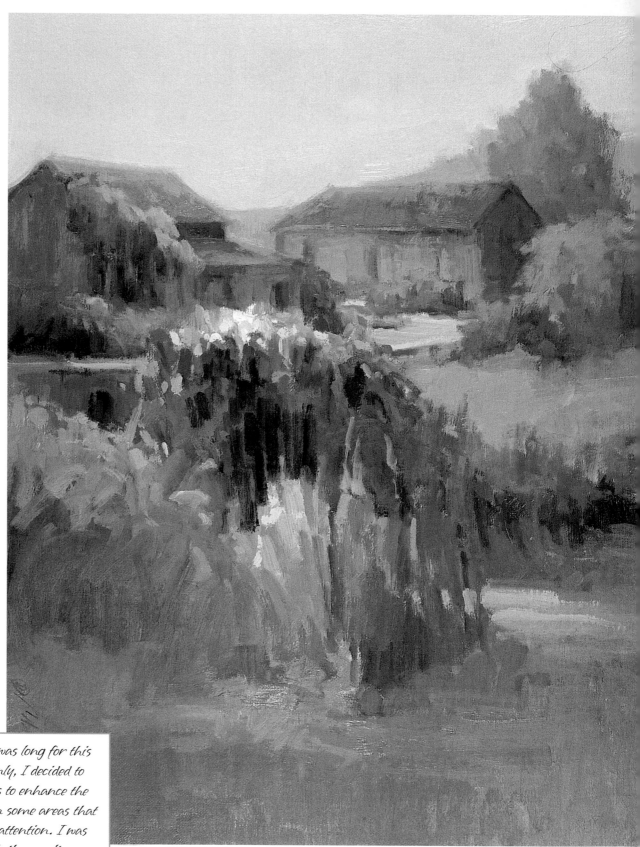

*My "fix it" list was long for this painting. Mainly, I decided to adjust the values to enhance the flowers and soften some areas that drew too much attention. I was pleased with the result.*

**Gentle Country**
18" × 14" (46cm × 36cm)
Collection of Nancy and Carle Robbins

# 5 Add Finishing Touches

I darkened the value of the building behind the light flowers using the same mixture from the bridge. This unified the temperature and values in this area, which supports the flowers better. Even though it works against the idea of lighter values being on the more horizontal planes and darker values on the more vertical planes, I reversed the values on the building to the right. I made the roof a darker, warmer value. By adjusting the values on these buildings, I created a ring around the center of interest, the flowers.

The foreground was a little too bright; it distracted from the center of interest. To tone down the foreground, I laid in some light but muted colors—grayed greens over the purer yellow foreground. I put in a Cadmium Yellow Light "path" behind the cattails to give the land a little contour and to lead the eye to the center of interest.

I removed the distant hill on the left. Using transition colors from the mixtures on my palette, I softened the tunnel, the light on the hedge above the tunnel and the rooflines near the sky. I also added more height to thc bush on the left with some darker-valued vertical brushstrokes.

## Showcase the Values

The digital photo of *Gentle Country* showcases the value pattern. While the warmth of the odd corner isn't so clear, the eye still moves along that light path to the center of interest.

## Final Analysis

There are very few dark areas in this painting. Dark areas create dramatic compositions—as in *Rapture* (page 121)—but the softness of this composition has a different, more subtle appeal. *Gentle Country* suggests the soft light found in many French villages. My memory and "soft impression" of France show in the welcoming middle values used throughout the painting.

### Broken Color

The saturated, broken color in the flowers catches the viewer's attention in an otherwise muted painting.

### Hard Edges

All the hard edges are located in the central area—along the buildings and in the foliage—serve to direct your eye to the flowers.

### Corner Theory

There are three warm corners and one cool corner. The odd, warm corner that invites the viewer into the composition. The eye enters the painting in the lower left of the painting, then circles along the light, saturated yellow path to the flowers. The warm, darker-valued buildings and bridge keep the eye centered in this area.

# Solutions for Painting Problems

At the very conception of a creative idea, problems begin. Successfully executing the concept is depends on knowledge, skill and the *application* of that knowledge and skill.

Creative minds rely on good equipment or resources, planning, support and confirmation to fulfill visions. Good equipment and supplies are stress relievers. Valid preplanning paves the road to success. Family and fellow artists' support generates the freedom to create unconditionally. Confirmation through agents and sales validate our purpose.

Creative spirits are often in total chaos. Creative bursts are adrenaline rushes. We are eager to capture the creative impulse and, as a result, the concept may fall apart under the influence of chaos. Overlooking the obvious drawbacks (in hindsight, of course), we rush into action without a plan. If plans and skills have evolved, masterpieces can be created under the influence of chaos. Artists fall into two categories: those who control chaos and those who embrace unbridled chaos.

Artists searching for growth and development control their energies up front. They tend to think through the problems that may arise even before they pick up a brush. They set goals for each creation prior to the execution. They envision a long path of trial and error before accolades. Artists who embrace unbridled chaos rarely plan ahead. They dream of a short path, often refute criticism, and wonder why there are no accolades.

Because we tend to wear our hearts on our sleeves, any criticism is difficult to acknowledge, especially in the beginning of a career. As time goes on, criticism becomes welcomed and less harsh, especially from our peers. Being objective with our own work is difficult. The isolated working atmosphere I endure led me to begin developing review lists. The lists help me critique my own work as best as I can. If I remain in a quandary after refer-

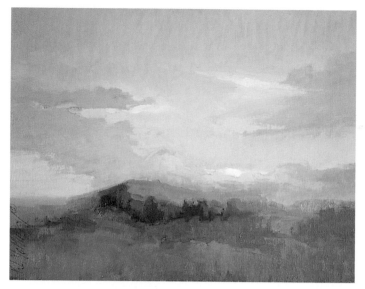

*Painting Problem*
The base color for this painting is Phthalo Blue + Alizarin Crimson + Phthalo Green. I temporarily lost my affinity for mixing colors and correct values and soon had a chalky painting.

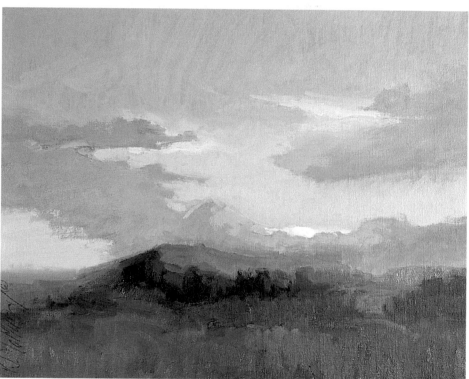

*Painting Solution*
I have come to terms with bad painting days. I can hold my frustration in check if I set the painting aside and try again on another day. When I came back to this painting, I brought up the light in the clouds one more time. I brought some of the cloud color down to the land. I then glazed the sky with thinned Phthalo Blue. I was able to darken the sky and add some luminosity at the same time.

**Terracing Clouds**
11" × 14" (28cm × 36cm)

ring to my list, I request advice from my daughter, Delaine. She can be brutal, but at least she is honest. With all humiliation set aside, I must admit that her record is 99.9% right—and she's not an artist. She simply listened to my "exciting" stories of knowledge whenever I returned from workshops.

For the paintings on the next few pages, the criticism was solely up to me. Some of the paintings came home from galleries. If some time has passed since the inception, I have to judge whether the plan fell apart or the "right" collector did not see the painting. The following paintings improved with minor corrections.

With each painting, I constructed a simple primary solution. Without a plan, I'd just end up slopping paint over everything and the results may not be favorable. I save the wet-paint-everywhere solution for the truly hopeless paintings. Occasionally, the hopeless paintings become my favorite paintings because I employed the "no holds barred" theory. I let the paintbrush rip. Fortunately, no one was watching.

If that doesn't work, I cut the painting up and throw it away. I cleanse my soul of the negative energy and make room for the positive energy to grow into a fresh creation.

## To Err Is Artful

Mistakes are welcome friends to artists. When we correct the errors, pleasant surprises surface. Sometimes an error is a pleasant surprise in itself.

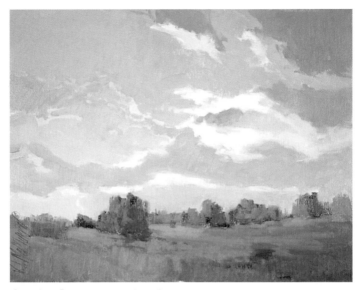

*Make Decisions Early*
I placed the large area of light in the dynamic point at the upper right. I omitted clouds on the upper left from the photo. This corner would be the entrance to the painting. I used Phthalo Green + Alizarin Crimson + Ultramarine Blue for the black. I added Cadmium Orange, Cadmium Yellow Light and Titanium White to lighten the value as needed.

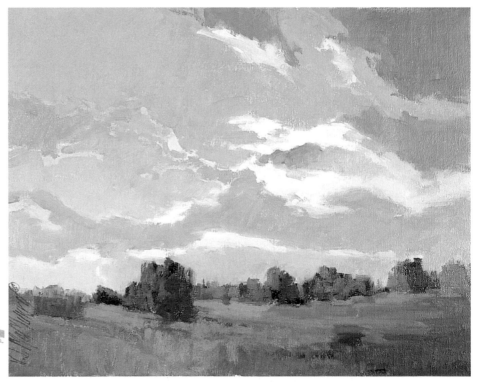

*Adjust as Needed*
I softened the lights hugging the right and left margin. This softening at the edges draws the vision to the point of interest. I glazed Phthalo Blue over the land to darken the value a step. Darkening the land also enhances the point of interest.

**Drifting Clouds**
11" × 14" (28cm × 36cm)

# Strengthen a Weak Composition

The lack of strong dark values makes this painting appear weak. Though this light, cool palette is unusual for me, I liked it—especially in the sky—and chose to leave it alone. I decided to begin with the water pattern and add a few trees before I approached the colors.

The size of the painting required more dark values. The strong perspective added strength to the painting. The spacing of the trees is irregular and makes nice vertical stabilizers, which adds energy to a horizontal format.

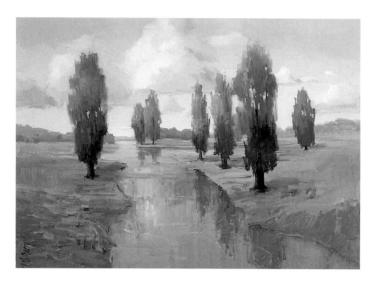

Grayed sky and softened clouds

Eliminated pair of trees to open space

Pushed little tree to background using grays

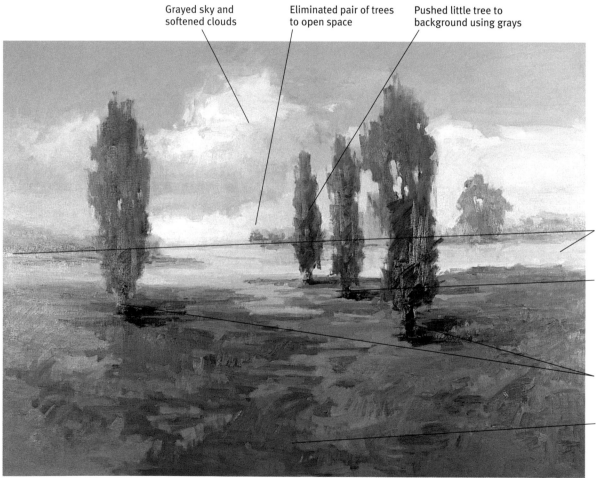

Took water at horizon to edges of canvas

Used dark reds at bottoms of trees to join with flowers

Added height at the bottoms of the two main trees

Eliminated water lead-in. Replaced with red flowers lead-in.

**Morning Marvel**
30" × 40" (76cm × 102cm)

# Redefine the Values

Because I liked the arrangement, I left the original composition *Yielding Yellow* intact. The painting needed more punch, so I redefined the values, added some temperature contrast and set some pure pigment against the muted colors.

Not only did I provide contrast by adding a cooler green to the trees, but I darkened the value as well. Now both temperature and value provide contrast in the trees, which frame the focal point.

To pop up the light values in the painting a little more, I lightened the light in the clouds and the backlit areas of the trees. The pure, saturated paint that I used provides contrast with the more muted colors throughout the painting. That worked so well that I added a few brushstrokes of pure pigment to the foreground.

## Prepare the Canvas for New Paint

New paint may flake off a varnished painting. Sanding the surface scratches it and ensures an adhesive surface for new paint. I use very fine sandpaper to lightly scratch the surface. Then, I wipe the surface several times to remove the dust. More vigorous sanding may be needed for areas of thick paint.

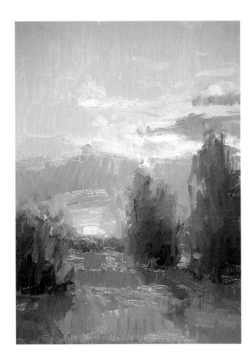

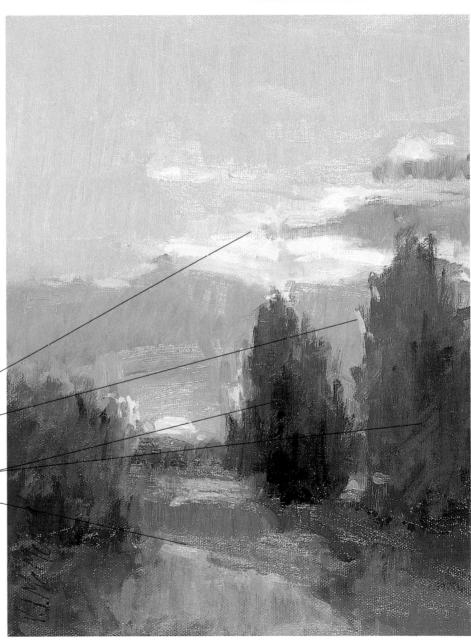

Lightened the light in the clouds

Strengthened the backlighting on the trees

Darkened the trees

Added purer pigments with a few strokes to the foreground

**Yielding Yellow**
12" × 9" (30cm × 23cm)

# Lose Repetitive Line and Shape

The composition is this painting's overriding problem. At its conception, I intended to portray the oak tree as the mighty symbol that it is, but I wanted the light to be the center of interest. I also planned to use a lower dynamic point, which places the mighty oak squarely in the middle of the right side.

Reluctant to do a major overhaul of the composition, I developed Plan B—enhancing the light in the sky, the point of interest. The previous paint was built up significantly, so I sanded vigorously. A sanded painting is my favorite painting surface. It is slick. I prefer very little resistance and drag on my brush. It's easier to blend lots of paint on the surface. After sanding *Sunset Salute*, I liked the oak tree. The muted colors seemed more accurate. The tree also became less dominant.

I made many other changes, but they only took thirty minutes to accomplish. My alternate plan turned out to be the path of least resistance. The point of interest now overpowers the oak tree. The painting doesn't seem to be split in half anymore. Eliminating one repetitive design, the hills, also helped the composition.

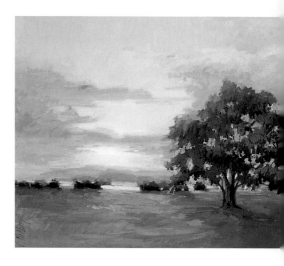

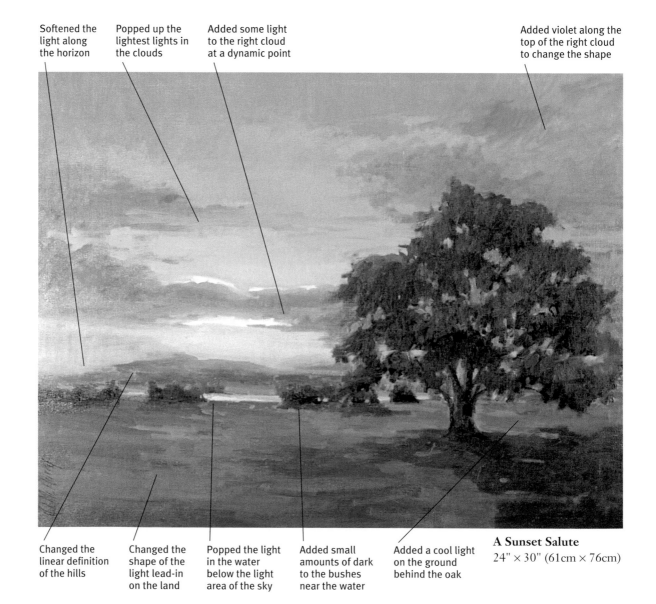

Softened the light along the horizon

Popped up the lightest lights in the clouds

Added some light to the right cloud at a dynamic point

Added violet along the top of the right cloud to change the shape

Changed the linear definition of the hills

Changed the shape of the light lead-in on the land

Popped the light in the water below the light area of the sky

Added small amounts of dark to the bushes near the water

Added a cool light on the ground behind the oak

**A Sunset Salute**
24" × 30" (61cm × 76cm)

# Modify Temperatures and Values

The upper-right corner in *The Moment* was too pure and didn't recede. My primary correction became changing the temperature of this corner. It's often tempting to update a painting to your current mood or to reflect some bit of knowledge you've picked up, but this can cause more problems. Before you know it, you're completely overhauling the entire painting. In this case, I avoided that temptation and corrected the painting with just a few touches of darker values, warmer temperatures and grayed pigments.

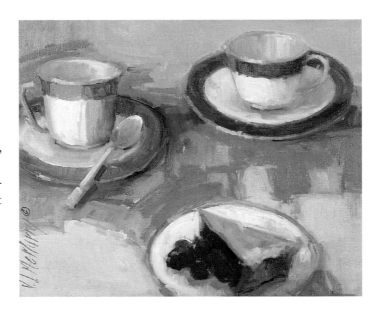

Added warmer lights on the cups and saucers

Adjusted the upper-right corner

Added a dark stroke under the spoon to add depth.

Added a stroke of dark cool red under the left saucer to bounce the red color

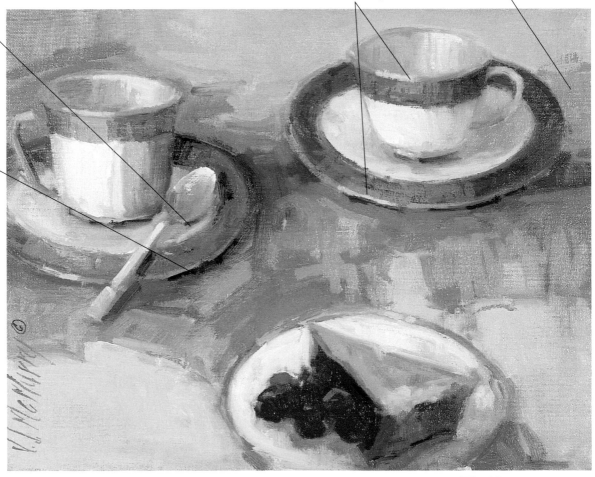

**The Moment**
11" × 14" (28cm × 36cm)

# Enhance the Value Contrast

An artists needs to correctly key in the values of the sky to set the remaining values in the right context. I didn't quite get that right the first time around, so this painting appeared rather, well, blah. I lightened the sky and enhanced a few darks to give the painting more punch. Once again, a few brushstrokes can make a significant difference.

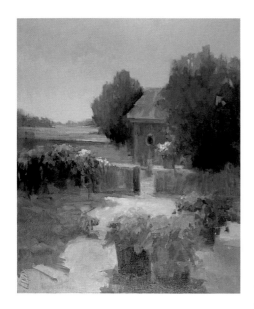

Lightened the sky along the horizon

Added the shadow of the tree on the roof, which softened the hard edge

Darkened the two major trees

Popped the light (one stroke) on the distant yellow field and flowered vine

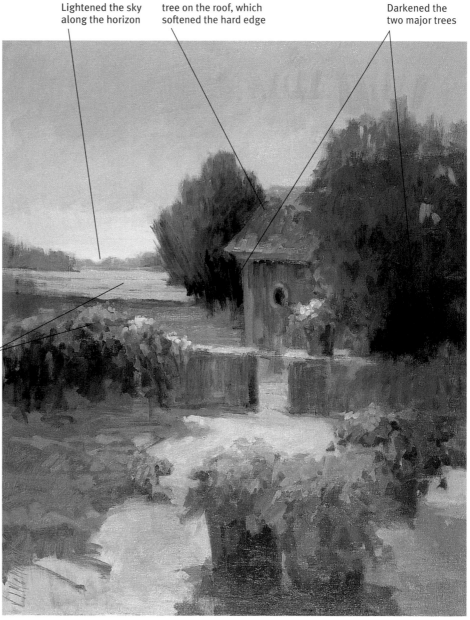

**The Courtyard**
24" × 20" (61cm × 51cm)

# Correct the Perspectives

The foreground tree on the left in this painting bothered me from the beginning. The perspective seemed off, yet I was unable to solve the problem then. To correct this painting, I focused on the tree and dove in.

I finally eliminated the tree altogether and replaced it with a field of warm broken colors, which gives the impression of wildflowers.

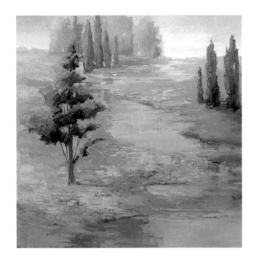

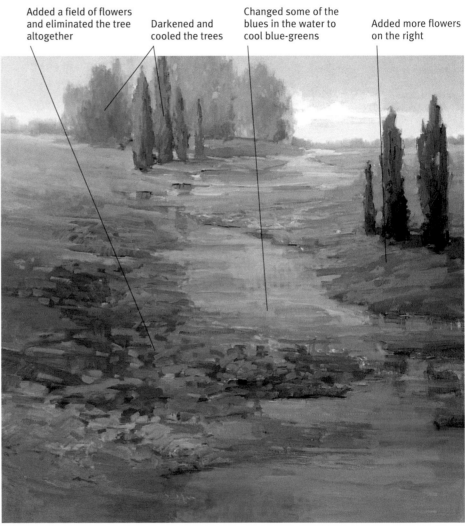

Added a field of flowers and eliminated the tree altogether

Darkened and cooled the trees

Changed some of the blues in the water to cool blue-greens

Added more flowers on the right

**Spirit of Spring**
36" × 36" (91cm × 91cm)

# Redefine the Dynamic Points

The clouds in this painting lacked definite points of interest; my eyes were bouncing everywhere. As my primary correction for this painting, I focused on establishing three hot spot in the clouds.

Once I decided to trail the flowers off the bottom edge, I knew that correct values were the key to successfully painting this area. I began abstracting the colors and enjoyed every minute. This insignificant portion of the painting became my favorite area.

Painting over an existing painting can be just as exciting as the surge of creativity you might feel standing before a fresh canvas.

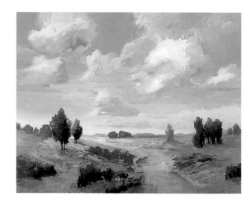

Scumbled over the light clouds on the top left and pulled the shapes together. Softened lines of the clouds near the edges.

Redefined three light areas in the clouds

Brought the flowers off the edge in the lower-left corner, chose the lower-left corner to be the odd corner and darkened the area

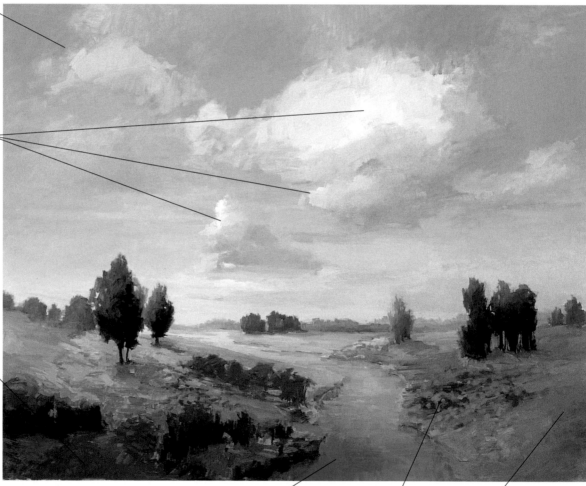

**Cloud Cluster**
40" × 50" (102cm × 127cm)

Added darker, cooler blues at the entrance of the water into the painting

Created a better pattern of flowers on the right bank

Painted over the small hedge in the right foreground to lose the repetitive (left hedge) tension

# Break Up Shapes and Diagonals

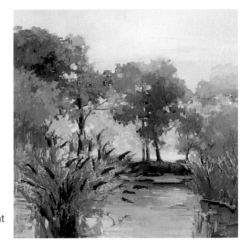

The design is distracting in this painting. The tops of the trees created an excessively strong diagonal, and there was no balancing counter diagonal. I decided to break this diagonal over the lightest horizon area.

It may seem like everything is getting repainted, but the majority of the corrections involved negative painting which is speedy. I made the right choice to divide the trees, and the location works well. The trees on the right pull the eye towards the water. I used the grays from the sky to create various values and maintained color harmony. The new colors also work well with the previous colors.

Moved the waterline up on the cattails and changed the blues to blue-greens

Redesigned the tree tops

Changed the middle tree to a violet-gray to soften the harsh areas of the painting and reinforce the underlying soft image

Popped the light spot in the sky

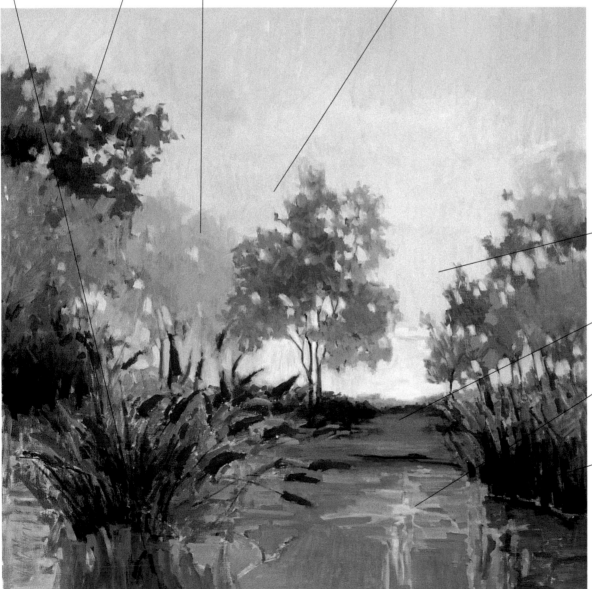

Added space between the trees to lessen the "wall of trees" effect

Cooled the temperature and altered the value of the land near the light

Gave the light reflection in the water a more interesting shape

Darkened the bush on the right in the water

**Luminous Light**
36" × 36"
(91cm × 91cm)

# Why and When to Rework

I have two reasons for reworking paintings. The first reason: My intuition nags me. I can't let go of the creative impulse, because I know that something is wrong. Solutions may not be apparent initially. Solutions may evolve during work on another painting. The second reason: I may not be happy with a painting and send it to a gallery anyway. I feel that if a gallery director likes it well enough to exhibit and promote the painting, it may have some merit. If the painting ultimately is returned, I will review my list (to the right) and look for oversights.

## Develop Strategies

As a novice painter, my brain was on overload. There were too many skills I had not developed. It was difficult to review my own work. I began developing review lists. I have heard stories of artists working on a painting for years. I don't have the patience to continue working and reworking a painting. I even destroy some paintings to move forward.

Whenever I do rework a painting, I select one or two items to rework. I may have to make minor adjustments to bond the corrected areas with the underpainting. A primary plan of corrections alleviates unnecessary aggravation.

## Review List

❏ Color is an obvious first consideration because the response to color is immediate and impulsive. Check color harmony. Are all colors repeated to create subliminal triangles?

❏ Incorrect color temperature is a common error that's easy to correct. Check for alternating temperatures.

❏ Check for correct values and distribution of values. Are the values correct? Do the darks support the lights?

❏ Check the composition. Is the perspective laid in correctly? Is the point of interest placed appropriately? Are the surrounding shapes supporting and directing vision to the point of interest?

❏ Check the corners. Is an odd corner established?

❏ Check the edges. Are the lines near the edges soft or hard? Are the breaks along the edges uneven? Does the eye stay in the painting?

❏ Check stabilizers and diagonals. Is there a stabilizer? If there are strong diagonals, is there an opposing diagonal?

❏ Review the message. Did the message stay on track? Do all the colors and design elements enhance the message?

❏ Check for authentic expression. Is there truth to this painting?

❏ Compare. Develop a habit of comparing new work with previous work. Also compare your work with your preferred list of old masters and contemporary peers. This will raise your awareness level and refresh your goals for the future.

# Conclusion

Will artists ever know all there is to know about color? Certainly not in my lifetime. I doubt I'll be bored in my old age. I'll continue to explore the millions of color possibilities with every possible design concept in search of the perfect painting. As I experience the ups and downs of life, my paintings will reflect the journey. The colors on my canvas will tell the story of particular moments in time, and there are many of those moments left to come.

In writing *Mastering Color*, I've sought to share new ideas and ways of perceiving color that you can adapt and make unique to yourself. Stay the course—spend time with your art and embrace the rewards of all your work. Open your heart to the colors that shine brightly in the light and glow in the dark, colors that express your past and your present. Express yourself in the truest colors.

**Serene Sunset**
8" × 10" (20cm × 25cm)

# Gallery

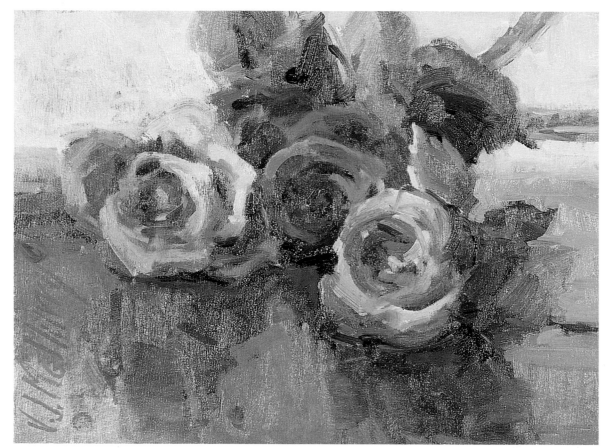

**Rose Study**
8" × 11"
(20cm × 28cm)

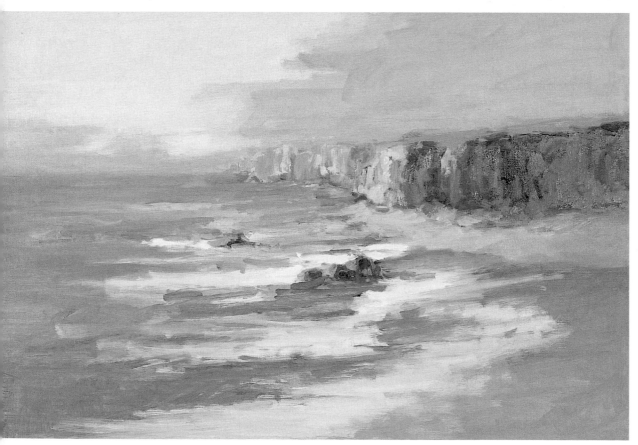

**A Majestic Bluff**
20" × 30"
(51cm × 76cm)

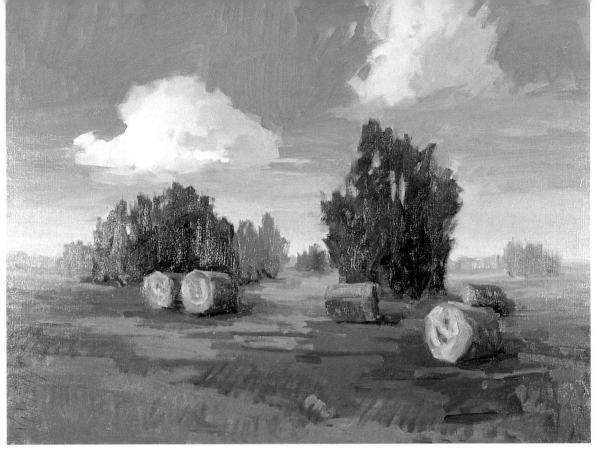

**Haybale Homage**
22" × 28"
(56cm × 71cm)

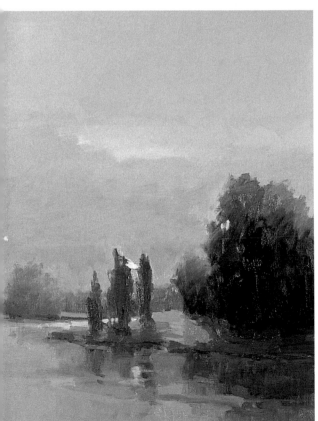

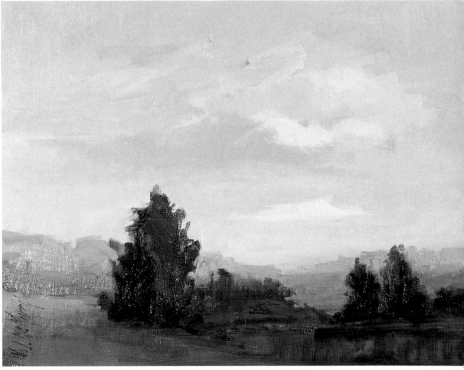

**Ends of the Earth**
14" × 18" (36cm × 46cm)

**Flickering Brilliance**
20" × 24" (51cm × 61cm)

# Index

# Add Color to Your World

**All you ever wanted to know about light and color...**

**Blue and Yellow Don't Make Green, 2nd edition** | Michael Wilcox

A total reassessment for the principles underlying color usage.

ISBN 0-9679628-7-0; PAPERBACK; 200 PAGES; # 32289

**Color Harmony in Your Paintings**
Margaret Kessler

Learn the basic principles of color harmony and how proper color can create expressive moods, unity, rhythm and eye-catching design.

ISBN 1-58180-401-6; HARDCOVER; 128 PAGES; # 32506

**Fill Your Oil Paintings With Color and Light** | Kevin MacPherson

Capture nature's glorious colors and luminosity in oils.

ISBN 1-58180-053-3; PAPERBACK; 144 PAGES; # 31615

**Exploring Color, revised edition**
Nita Leland

Create clean, vibrant color every time! Over 83 exercises show you how to catch the perfect color.

ISBN 0-89134-846-8; PAPERBACK; 144 PAGES; # 31194